M000287016

IN EXCHANGE FOR GOLD

The Legacy and Sustainability of Artisanal Gold Mining in Las Juntas de Abangares, Costa Rica

Richard A. Niesenbaum
Joseph E.B. Elliott

IN EXCHANGE FOR GOLD

The Legacy and Sustainability of Artisanal Gold Mining in Las Juntas de Abangares, Costa Rica

Richard A. Niesenbaum
Joseph E.B. Elliott

COMMON GROUND RESEARCH NETWORKS 2019

First published in 2019
as part of the On Sustainability Book Imprint
doi: 10.18848/978-1-86335-126-3/CGP (Full Book)

BISAC Codes: NAT011000, HIS007000, PHO014000

Common Ground Research Networks
2001 South First Street, Suite 202
University of Illinois Research Park
Champaign, IL
61820

Copyright © Richard A. Niesenbaum and Joseph E.B. Elliott 2019

All rights reserved. Apart from fair dealing for the purposes of study, research, criticism or review as permitted under the applicable copyright legislation, no part of this book may be reproduced by any process without written permission from the publisher.

Library of Congress Cataloging-in-Publication Data

Names: Niesenbaum, Richard A., author. | Elliott, Joseph E. B., author.
Title: In exchange for gold : the legacy and sustainability of artisanal gold
 mining in Las Juntas de Abangares, Costa Rica / Richard A. Niesenbaum,
 Joseph E.B. Elliott.
Description: Champaign, IL : Common Ground Research Networks, [2018] |
 Includes bibliographical references.
Identifiers: LCCN 2018046537 (print) | LCCN 2019000316 (ebook) | ISBN
 9781863351263 (pdf) | ISBN 9781863351249 (hbk : alk. paper) | ISBN
 9781863351256 (pbk : alk. paper)
Subjects: LCSH: Gold mines and mining--Costa Rica--Abangares (Canton) | Human
 ecology--Costa Rica--Abangares (Canton) | Sustainable development--Costa
 Rica--Abangares (Canton)
Classification: LCC HD9536.A23 (ebook) | LCC HD9536.A23 N54 2018 (print) |
 DDC 338.2/7410972866--dc23
LC record available at https://lccn.loc.gov/2018046537

Cover Photo Credit: Joseph E.B. Elliott

Table of Contents

ACKNOWLEDGEMENTS

This project would not have been possible without the support of our friends in Las Juntas de Abangares in Costa Rica. First and foremost, we are grateful for the friendship and support of Carlos Edwardo Fonseca Fonseca and Elieth Montoya Gamboa. Carlos and Elieth first introduced us to the town and history of Las Juntas, and quickly became a family to us and our students. They have worked tirelessly to preserve both the cultural and natural history of the region, and to develop economic opportunity through eco-educational tourism centered on mining and the environment. Growing up in Las Juntas, Elieth and her family have lived the history that we describe here and we are extremely grateful to her for sharing it with us. Her mother Ofelia was the town's first kindergarten teacher. Carlos shared with us his passion for the environment, for sustainable agriculture and forestry, and for his community. Another resident committed to documenting the history of Las Juntas, Lilliam Román Zeledón, provided historical photographs that came from her personal collection.

Over the past ten years, we have met and interviewed dozens of residents of Las Juntas and the surrounding communities, and every one of them has been gracious and proud of their natural, historical, and social environment. We dedicate this work to these people of Las Juntas who in essence have become our teachers by engaging us in this fascinating story. They taught us how to think about real sustainable solutions to the issues that confront them. Finally, this work would not have been possible without the support of numerous colleagues and students who have accompanied us to Las Juntas and joined our dialog to help us better understand this community. Included among them are Tammy Lewis, Barbara Gorka, Sarah Harris, Maetal Rosenberg, and Carolyn Blake. Finally, we are grateful to Muhlenberg College, and to our families and friends for their support and encouragement.

Introduction: The True Cost of Gold

Gold is one of our most precious commodities. From ancient civilizations to present day, gold has been sought after and treasured, and its discovery has created both ephemeral and lasting fortunes. It serves as both the symbolic and actual currency of the wealth of civilizations. Gold is our jewelry, our ornamentation, our money. We use it to reflect our commitment to God and to each other. In times of uncertain economic condition, gold offers economic security for individuals and nations. It is the historic standard of excellence and value, and it has often played a role in shaping the course of history.

The drive to possess gold has reshaped the social fabric of communities, states, and nations. However, this transformation has often come at a great cost, as lives and the environment have been sacrificed in exchange for gold. The mining of gold has drastically altered landscapes and severely affected the environmental and public health on regional and global scales. In this sense, gold has been acquired through a process of double exploitation, that of both the land from which it is mined; and the people whose labor and lives have unearthed it and shaped it into the treasures we desire.

Gold has been mined in the area surrounding the small town of Las Juntas in northwestern Costa Rica for over 100 years. In the beginning, large-scale North American mining companies exploited the people who worked for them. The miners worked under dangerous and difficult conditions for low wages that mostly went back to the company for food and housing expenses. Subjected to the indignity of full body searches and physical and verbal abuse, miners mounted a rebellion in 1912 that resulted in numerous deaths. There is no record of anyone in this community ever getting rich from gold mining. Instead, the foreign industrialists reaped the profits. Accordingly, it is said in Las Juntas, "...miners died with only the seat of their pants." The environment was similarly exploited by the early mining operations. The surrounding landscape was deforested, and direct runoff from the mines silted local streams. Large processing plants discharged mercury and cyanide into the air, the soils and the rivers from which the community had and continues to breathe, grow its food, and draw its water.

In today's time the large-scale mining operations are all gone, but the old tunnels are still worked by local artisanal miners or *coligalleros* as they are called in this town. Ironically, the current miners are emboldened by a heritage that was once imposed on them by outsiders, and the town has built a small museum to honor its mining heritage. But the lack of capital and infrastructure makes the situation in the tunnels more dangerous than ever. Young men are imperiled deep underground, threatened by the collapse of tunnels or asphyxiation. Miners process the gold using

mercury in their own back yards along the rivers, threatening their own health as well as the ecology and public health of this community and that on a global scale.

Contradictions abound. As the rest of the Costa Rica develops ecotourism and the preservation of nature as the basis of its economy, Las Juntas attracts neither tourists nor any associated benefits. As the rising price of gold motivates more locals to enter the mines, a regional economy centered on environmental exploitation grows amid a nation dedicated to conserving natural resources. In response, people from outside of this community now attempt to discourage all mining, an ironic threat to a way of life and a heritage that was originally generated by outside mining interests. Costa Rica has taken the lead in the areas of sustainable development, conservation and preservation, debt-for-nature swaps, renewable energy, and carbon sequestration and credits. Here we consider whether it is possible for artisanal gold mining to meet the economic, social, and environmental conditions of sustainability, and if this community can develop a rational organization of collaborative, locally controlled, safe and environmentally sound mining that might provide a viable, non-exploitive existence.

The human experience and ecology of Las Juntas are tightly linked. They shape the architecture, the culture, the environment, and the current economy of this community. We document this linkage through the words of a natural scientist and the images produced by a documentary photographer. The photographs are not meant to illustrate or support the text, but rather tell the same story in a different way. Thus, the words and images could easily stand alone as independent works; however, they do come from a close, interactive collaborative process that has resulted in two forms of documentation. We hope that when offered together they reflect an integration and synthesis of perspectives. This type of collaboration between a scientist and an artist is rare, but we believe it is essential for truly understanding the give-and-take among cultural heritage, social condition, and the ecology of a specific area.

We offer this is a case study. We hope that is of value to the people of Las Juntas, and that it generates interest and visits to this distinctive community. We also wish to honor this community and its rich culture and history. We have produced an archival set of images for the people of Las Juntas so that they can preserve and reflect on their heritage and current situation. But like most case studies, there are lessons to be learned that we hope will be more broadly applied. Artisanal gold mining is a global issue and provides an important source of livelihood for rural communities throughout the world. It also currently represents the world's leading source of mercury pollution (Wade 2013), and is one of the motivating factors for the Minemata Convention held in 2013 in Japan to address the toxic effects of mercury in the environment (McNutt 2013).

One of our goals for this project was to increase awareness of the environmental and human implications of gold extraction by adding a personal element to this story. We also suggest some sustainable approaches to protect the environment and public health of the region by recognizing the needs of individuals and communities whose heritage and livelihood come from gold mining activity.

CHAPTER 2

The Landscape

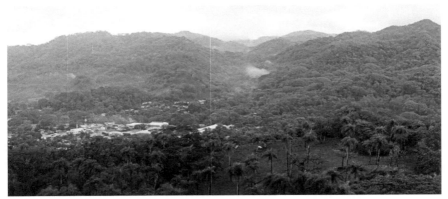

Plate 2.1: Las Juntas and the Abangares watershed, 2013

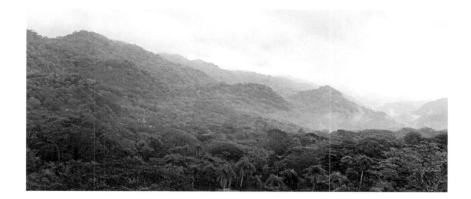

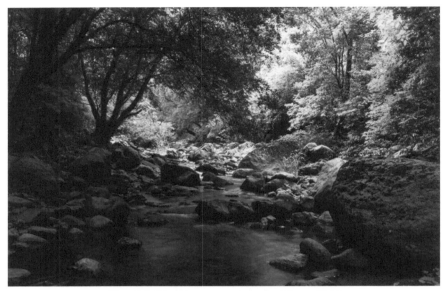

Plate 2.2. Rio Abangares, above La Sierra, 2016

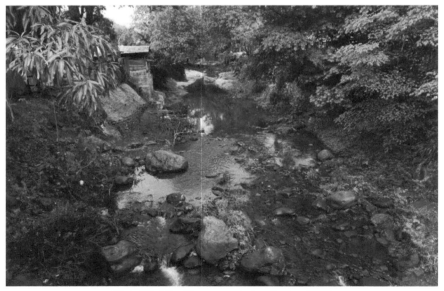

Plate 2.3. Rio Abangares, in Las Juntas, 2013

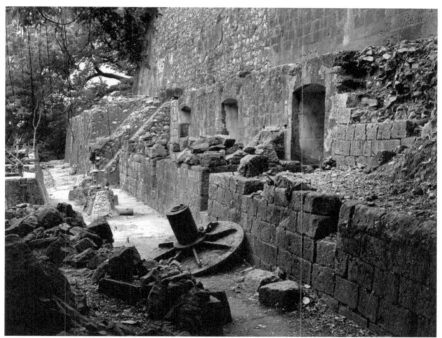

Plate 2.4. Remnant foundations of Los Mazos gold processing plant, 2004

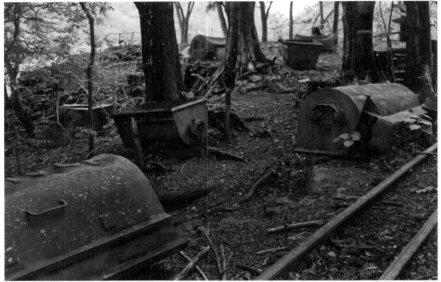

Plate 2.5. Ore carts at Los Mazos, remnants of Keith's mining operation, 2013

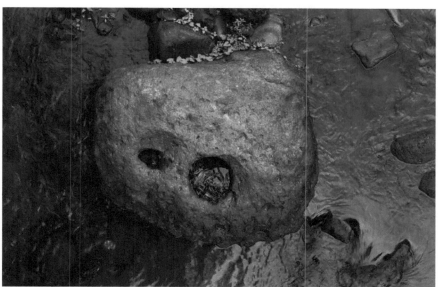

Plate 2.6. Rock in the Abangares at Las Juntas,
showing cavity used for hand grinding of gold ore, 2013

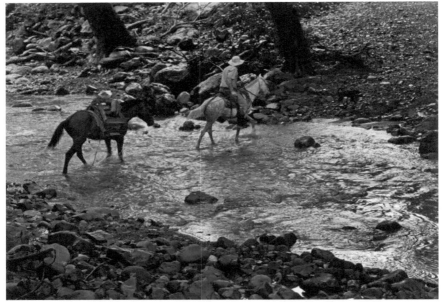

Plate 2.7. Horseman crossing the Abangares above La Sierra, 2013

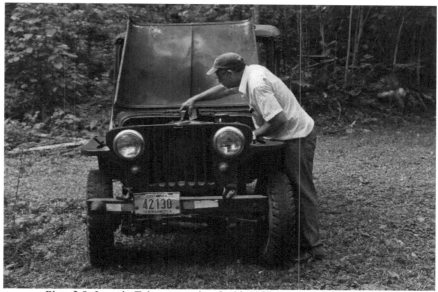

Plate 2.8. Joaquin Talavares caring for his Willys Jeep, Las Juntas, 2011

In Exchange for Gold

A Rich Natural History

Our story takes place at the interface between humans and their environment. In this chapter we would like to present a brief natural history of Costa Rica and the area of Las Juntas as a background setting for our case study. We offer a perspective on the geography, geology, meteorology, and rich biodiversity. We do this with the context of agriculture, deforestation, and the need and efforts to protect this rich natural environment to provide a better understanding of both historical and current day gold mining especially as it relates to sustainability.

THE RICH COASTS

Costa Rica is located in the Central American tropics, approximately 10 degrees north of the equator, with the Caribbean to the east and Pacific Ocean on the west. It is a relatively small nation, comprised of about 51,000 square kilometers, approximately the size of West Virginia in the US. Although Costa Rica occupies only 0.03 % of the surface of the globe, it contains a much larger proportion of the world's biodiversity, nearly 6 %. Costa Rica is in the business of protecting biodiversity, with about 25 % of its natural land set aside for conservation (Inbio, 2013). Historically, the Costa Rican economy was dominated by beef, coffee, and bananas. The sum of these has been superseded by tourism, specifically ecological or ecotourism, which brings millions of visitors per year to experience the protected biodiversity and the conserved areas in which they occur. Gold has never been a major portion of GDP, but we would like to demonstrate that the development of gold mining was linked to these agricultural endeavors and could potentially be tied to tourism as well.

Geologically, Costa Rica offers many opportunities to see plate tectonics in action. It is situated in an active subduction zone, on top of the boundary between the submarine Pacific Cocos and Caribbean Plates. The Cocos Plate is continuously moving northeastward and as it collides into the Caribbean Plate along the Pacific coast of Central America, it is thrust downward or subducted below the continent and the Caribbean plate until it reaches the earth's hot mantle. This results in the formation of magma. Over time this magma has risen up forming an arc of volcanoes above the subduction zone running the length of the country. These large volcanic mountain ranges include a number of currently active volcanoes and frequent accompanying seismic activity. The Costa Rican landscape that is dominated by seven of Central America's 42 active volcanoes plus dozens of dormant or extinct cones reflecting both Costa Rica's past and present volcanic activity. In the Central Valley are the volcanoes Poas, Barva, Irazu, and Turrialba. Further northward, Central

America's most currently active volcanoes, Arenal and Rincon de la Vieja attract tourists and have also been developed for geothermal energy production.

This strong geological activity has resulted in the accumulation of rich volcanic soils that are well suited for and support diverse agricultural activity. This includes the production of what arguably may be one of the highest quality coffee crops on the globe. This volcanic activity has also resulted in the production of gold deposits especially in the northwestern mountains of the country. Gold is formed when water below the ground is heated by lava and then intrudes the rock causing minerals to leach from it. Under specific temperature and pressure regimes, this epithermal mineralization results in the deposition of gold near the surface of volcanoes.

The tropical climate of Costa Rica is primarily due to its location near the equator and the downward movement of moist air in the intertropical convergence zone. Costa Rica's geological history also contributes to the tremendous variation in climate. The volcanic mountain ranges that run down the center of the country create a steep continental divided with peaks rising to nearly 4000 meters. The trade winds that move from east to west help determine regional climate as they interact with this steep divide. As these winds move across the warm Caribbean Sea they become saturated with water. The moisture laden winds then collide with the eastern slopes of the mountain ranges, and are rapidly forced upward where they cool and lose their capacity to hold moisture. This orographic effect creates a consistent rain shadow on the eastern slopes and coastal regions. Thus, the windward slopes on the Caribbean side of the central mountain ranges are very wet for nearly the entire year with seasonal patterns of intensity, and consistently warm temperatures averaging 27 °C (82 °F).

The lee or Pacific side of the orographic effect goes through seasonal dry periods that are extremely hot with average temperatures above 32 °C (89 °F). The capitol city, San Jose, is located on a high altitude plateau encompassed by the parallel and converging mountain ranges that run north-south down the center of the country to form the Central Valley. This region's climate benefits from the orographically determined climate and its distance above sea level. The central valley's year round mean temperature of 23 °C (74 °F) and lower humidity have earned it the title as the "land of eternal spring". One Central Valley town, Atenas, just north of San Jose has been labeled as having the "best weather in the world" by the National Geographic Society.

The variation in climate with altitude, along the east-west gradient, and the seasonal north-south movement of the intertropical convergence zone causes Costa Rica to have a large diversity of habitat types, including five forest types. These include tropical rainforest on the Caribbean slopes, cloud forests along the ridges, and tropical dry forest along the Pacific coasts. We once polled a group of Costa Rican students about how they valued the rain forest, and without exception they would request clarification of the specific type of rainforest. For the typical Costa Rican, the term tropical forest is simply too general.

Costa Rica has one of the highest densities of biodiversity (species/unit area) in the world including more than 130,000 species of insects, nearly 1,000 species of vertebrate animals, and a spectacular diversity of plants and fungi, many of which are

endemic meaning that they occur only in Costa Rica. The determinants and maintenance of this diversity have been driven by high rates of primary production and the relatively benign conditions associated with a tropical climate coupled with its unique geography and paleogeography. As the climate varies by altitude and the wind driven determinants of rainfall, there is a rapid turnover of habitat types over small distances. This in turn contributes to the great diversity of organisms. A large variety of soil types resulting from variation in volcanic deposition and climate also contribute to this diversity. During prior ice ages, northern species gradually extended their range south towards the tropics, which served as refugia for cold sensitive species. This coupled with the fact that Costa Rica is situated on an isthmus between north and south America has allowed it to serve as a trap as species moved during the advance and retreat of glaciers.

Deforestation has been a major threat to this biodiversity as nearly 80% of Costa Rica's land has been deforested since World War II, much of it for cattle production. Recognizing the value of maintaining ecosystems and biodiversity, Costa Rica has become a leader in protecting remaining natural areas, and in acquiring and restoring those that have been previously degraded. A little over 25% of Costa Rica's territory is now under some category of biodiversity conservation including both national parks and private conservation efforts (InBio, 2013). There are 11 conservation areas managed by the Ministry of Environment as part of an effort to take a decentralized approach to biodiversity management (InBio, 2013). An important focus of these conservation efforts has been to seek active participation of communities surrounding protected areas, and strong scientific support that both assess biodiversity and evaluates the collective benefits of these protected areas (InBio, 2013).

FROM THE CENTRAL VALLEY TO LAS JUNTAS

The journey northwest to Las Juntas typically starts near the capitol city of San Jose, situated in the Central Valley. San Jose is the home of tour guide Luis Torres, who was originally from the village of Tortuguero that is located on the northern Caribbean coast. Of Caribbean descent from a town where the majority of people emigrated from Jamaica, Luis is darker skinned and English is his native language. His fluency in English made him employable as a naturalist tour guide for the ecotourism-based economy. He started as a local guide conducting nature and fishing tours in Tortuguero before obtaining more formal training through the International Union for Conservation of Nature (IUCN) and the Costa Rican Institute of Tourism. Luis moved to San Jose to be near the larger tour companies that guide throughout Costa Rica. The move was motivated by a search for a better standard of life for himself and his family. Luis and many like him believe that working as a guide contributes to conserving biodiversity because tourism adds economic value to natural habitat and serves to limit poachers and illegal loggers. Prior to becoming a guide, Luis and many of his peers had been loggers and hunters, but they saw an increase in their standard of living when they made the change to tourism. He now works to protect the habitats that he previously exploited. His story reflects the potential

benefits of ecotourism as a means to increase the standard of living of local people while conserving habitats and their biodiversity.

As we travelled from the San Jose airport to Las Juntas in the Guanacaste province with Luis, we departed the Central Valley over the top of the Central Mountain Range and head northwest on the Inter-American Highway towards Nicaragua. Signs on the opposite side of the road indicate points as far south as the border with Panama. As we move from the Central Valley over the mountains down towards the lowlands of Guanacaste along the northern Pacific Coast, it becomes apparent that despite its humble size, Costa Rica looms large in terms of its diverse geology, geography, and biological wealth. The heat and humidity begin to increase in intensity as we move through dense patches of thick green forest alternating with open pastureland, the result of tropical deforestation undertaken by farmers and ranchers. During the 2-3 hour drive to Las Juntas we experience a multitude of habitat types, and this rapid turn-over of climatic and habitat types over small changes in latitude and altitude offers a sense of how this contributes to this small nation's high biodiversity.

This is the same route that the gold buyers and sellers take when they move between the mining regions of Guanacaste to the capitol city; often trading in their cars on each trip to maintain a degree of stealth. Also often travelling this same route are much of the cattle from Guanacaste in open-topped cattle trucks on their way south for auction, slaughter and export.

During this passage, we not only witness the transition in climate, geography, and ecology, but can also observe gradual cultural changes. Departing the Central Valley we pass fancy hotels, familiar fast-food chain restaurants, large dairies, Intel and other technology-based businesses, the factory where the famous *Salsa Lizano* is made, and used car lots and furniture stores. Within a few miles the landscape transitions to a rural environment dotted by small towns and settlements. We pass Esparza, Miramar, and Rancho Grande with their humble homes and small business that offer typical food and *Cerveza Imperiale*. We cross dozens of rivers on narrow bridges. The driver has to avoid many travelling by foot or bicycle along the highway, and pass lumbering semi-trucks on the uphill slopes. The pace of life slows as we move into the tropical heat on the Pacific side of the central mountain ranges. We transition from the global commercial and technology market to a drier, more traditional world, where cattle ranches, worked by *vaqueros* (cowboys) spread out across the foothills and lowlands of Guanacaste.

GUANACASTE

Named after the Guanacaste Tree, *Enterlobium cyclocarpum,* Guanacaste is the northwestern most province of Costa Rica. Ironically, this national tree of Costa Rica and one of the best-known trees in the province that bears its name did not naturally occur in Costa Rica before the Spaniards arrived. The seeds from the ear-shaped fruits (hence the scientific name *Enterlobium*), were most likely transported southward from Mexico in the guts of Spanish horses and cattle (Janzen, 1983). Cattle ranching came

to dominate this region as it was converted from tropical dry forest to pasture on a massive scale over the past 400 years.

The far western portion of Guanacaste is part of a belt of what was once tropical dry forest that ranged from the middle of the west coast of Mexico to the Panama Canal. Also referred to as Pacific Mesoamerican dry forest, it is characterized by up to 2500 mm of precipitation during rainy part of the year, and no rain during the remaining dry season (Janzen, 1983). It is extremely hot during the dry season, which occurs from December to May. This dry-hot season is referred to as *verano* or summer even though it coincides with the northern winter. The rainy season, from late May through November is winter in Guanacaste. Rain slows and things heat up for a few weeks in July; and this is referred to as *veranillo* or little summer. It is hot here, especially during the dry season when average temperatures are around 32 °C or 89°F with daily highs maxing out well beyond 100 °F.

Today, less than 2% of this now endangered tropical dry forest exists in its original undisturbed form. Now the dominant species are cattle, and pasture grasses that have been imported from Africa. The annual dry season and the rich volcanic soils made it easy to clear forest and convert it to savannah style beef factories. There is still much evidence of cowboy or ranchero culture as we drive through the hills and flatlands of this region; a region with large chunks of pasture carved out of what was once contiguous forest. The cows are of the Brahman variety with large humps and droopy ears. This variety is well suited to the intense heat and long periods of drought in this region. It is common to see men on horseback donning cowboy boots and white cloth cowboy or *tico* hats. The music, dance, and food reflect this cowboy culture; and are reinforced by the annual rodeos and agricultural celebrations that distinguish this region from other parts of Costa Rica.

In addition to its ranching and cattle history, Guanacaste served as the setting of another important event in the history of Costa Rica. William Walker of Tennessee and a medical graduate of the University of Pennsylvania started a war in Central America with the primary purpose of extending the "glory of slavery" southward. Walker's objective was to form a confederacy of southern American states that would include the Spanish speaking nations of Central America including Costa Rica, Nicaragua, and Honduras. In 1856, he invaded Northern Guanacaste where he ultimately lost in battle to Costa Rica's machete bearing *campesino* army that chased Walker's troops out of Costa Rica to Rivas, Nicaragua. This peasant army's victory has become a point of national pride, and the site of the battle, Santa Rosa, was made into a museum and National Park (Biesanz et al., 1988). The battle's favorite son, Juan Santamaria the drummer boy who courageously died while setting fire to the Walker's encampment in Rivas, has become a nationalistic symbol and is the name-sake for the nation's primary international airport near San Jose.

The historical site of Santa Rosa in Guanacaste is now part of a much larger effort to conserve both cultural history and the endangered tropical dry forest habitat of this region. In 1989, Santa Rosa was incorporated into the much larger Guanacaste National Park, a world heritage site that covers an area of about 240 square kilometers (Janzen, 1986). The park includes not just the dry forest along the Pacific, but the moister mountainous habitats up and over the slopes of the Orosi and Cacao

volcanoes. These provide migratory refuge for some of Costa Rica's 300 species of birds, 10,000 species of insects, and numerous mammals during the harsh dry season. This effort, led primarily by Dr. Daniel Janzen of the University of Pennsylvania, ironically the same institution that trained William Walker, is one of the first conservation projects that had taken a "Biocultural" approach with a focus on both the needs of the biota and social cultural needs of the people in the region (Allen, 1988). Central to this idea was the education of local ranchers and cowboys as park guards and parataxonomists who are trained to identify and catalog the areas biodiversity. In this way habitats, biodiversity, and the standard of living of those who have traditionally made their living by exploiting them are preserved.

ABANGARES, LAS JUNTAS, AND LA CUENCA

The small quiet town of Las Juntas is located in the county of Abangares in the Guanacaste province. One can get there by turning off of the Pan American Highway at La Irma, a popular rest stop, and driving the five-kilometers to the center of town. The Abangares river runs through the center of Las Juntas playing a big part in the local ecology and culture. Dependent on rainfall, its flow ranges from a mere tickle to a dangerous torrent of muddy water that the locals refer to as *chocolate* or *café con leche*.

Joaquin Talaverez has lived in Las Juntas his entire life. He has spent most of it as a biology teacher in the local high school, as a scout leader, and as a proud father to his three sons. Plaques throughout Las Juntas commemorate Joaquin's role in community development, ranging from youth activities to the construction of a small commercial center in town. He can be seen at most community events, arriving in his 1948 Willys Jeep, a vehicle made in the USA that he acquired at the Panama Canal. In addition to his home in town directly across from the high school, he has purchased additional land consisting of old pasture, on which he is re-growing the tropical forest that once stood there. He has named it *Bosque Silencio* or silent forest.

For Joaquin, conservation is about compromise. Recently when asked about progress on his forest, he replied that things were going well since Costa Rica's government-run electrical telecommunications agency, *Grupo ICE* (Instituto Costarricense de Electricidad), had just placed a new cell tower on one of his highest hill tops. As North American environmentalists, we were conflicted by this news, but Joaquin was clear about the benefits. Income generated from this deal has allowed him to acquire more land, and hire economically limited members of the community to maintain that land. The tower also provides improved cellular coverage needed for the economic development of Las Juntas proper. This was a powerful lesson for northern conservationists like us who tend to focus on biological data, and aesthetics, often forgetting about the human needs of the region. It has become clear that ignoring these needs often ultimately results in more environmental degradation.

During any forest hike with Joaquin, he easily reveals his primary goal of preserving and reforesting *la cuenca* (the watershed). Any forest, temperate or tropical, can be thought of as a collection of watersheds. Watershed is the term used to describe the geographic area of land that drains water to a shared destination. Like

a funnel, it collects the water through a common set of streams and rivers and channels it into a larger river or estuary. The highest ground around the watershed forms its boundaries. Any activity that changes soil permeability, vegetation type or cover, water quality or quantity, or rate of flow at higher points within the watershed can drastically influence downstream water quality. Land use practices such as clearing for timber or agriculture, developing and maintaining roads, mining, housing, waste disposal, and water diversions may have cumulative downstream environmental consequences. Biologists and politicians are beginning to recognize the importance of a watershed approach to environmental protection.

The Abangares watershed includes the 48,000 hectares of land and tributaries that drain into the Abangares River that runs through Las Juntas and ultimately into the Gulf of Nicoya and the Pacific Ocean. The watershed provides drinking water for the more than 15,000 people that occupy it, none of whom have access to wells because of the particularly deep water table and the thick volcanic rock that lies above the aquifers. The land that this watershed drains consists of irregular slopes of what was once all pre-montane humid forest shaped by a volcanic past. With a dendritic hydrology, and a six month rainy season, the watershed consists of gallery forest, an evergreen corridor running along rivers in otherwise dry habitats that normally cannot support such vegetation. Its canopy is dominated by trees named Pochote, Guanacaste, Cenízaro, and Bombicopsis that support Capuccin and Mantled Howler monkeys, iguanas, toucans and many other bird species; a mixture of both wet and dry forest species. Today less than one third of the watershed remains forested with the rest cleared for cultivation, cattle ranching, mining, and habitation.

Well above the town of Las Juntas, three major tributaries, Río Aguas Claras, Río Gongolona, and Río Boston join to form the beginning of the Abangares. As its name suggests, Aguas Claras has been and remains quite pristine and clear. The Boston, which derives its name from the late 19th century gold mine and processing operation that was founded on its banks by a North American company with connections to the Boston Fruit Company, is not so pristine. The remnants of this operation are still worked by local independent miners, and the quality of water in the Boston reflects both the historical and current impacts of this activity. The biggest concern is the influx of mercury into the watershed that serves the people of Las Juntas. Recognizing the potential for human harm, the Costa Rican government constructed an aqueduct system that collects water from Aguas Claras above where it joins with the Boston, and transports it to a treatment plant where it is then distributed throughout Las Juntas.

Alberto Duran who has lived in the upper Abangares Watershed his entire life is a former employee of a Canadian gold mining company that is no longer operating in the area. He is currently employed by the municipal government to maintain the system of aqueducts that runs along the banks where he used to play as a child. In a garden near a settling apparatus that he maintains, Alberto and his boys grow vegetables and watch a nest of young toucans. Alberto expresses concern that during the dry season, Aguas Claras does not have the volume of water to support the community below with clean water, and that there are days when flow is completely shut off. He's afraid that the frequency of this will increase with climate change. As

the supply of clean water becomes increasingly limited, the people in Las Juntas will likely collect water downstream from the Abangares which carries a mixture of the polluted Boston and cleaner waters. In 2013, the low water in Aguas claras forced the water authority to draw water from the polluted Boston. In response to this, some have installed filters capable of removing mercury from the drinking water, though it is an option not available to less economically advantaged families.

Joaquin shares Alberto's concern about the water supply. He says that in addition to mining, cattle ranching and deforestation are degrading even the cleanest tributaries. He is working with the Ministry of the Environment (MINAE) to convince ranchers to grow trees on the banks of the rivers thereby creating a buffer zone between the pastures and the drinking supply. He has done this with his own *Bosque Silencio* and he is exploring ways to acquire and reforest land in the upper reaches of the watershed. With recent success, forest has begun to replace pasture and is providing protection for this important resource. Joaquin is now working with Ministry officials to ultimately build a new water collection site on the other unpolluted tributary, the Gongolona, to supplement the limited Aguas Claras. He recognizes that this will be costly, but views it as essential for his community's survival. As of 2018, plans for such infrastructure have been developed and the project construction was underway.

An even greater challenge is to protect the water through the regulation of mining activities. Unfortunately, as other areas of the economy slow, and the global market for gold continues to grow; independent, unregulated mining is on the rise. The input of mercury and polluted wash from mining activity represents an increasing threat to the environment and public health that depends on this watershed. Economic alternatives are few for the poor, less formally educated men and women who engage in mining. Committed community activists like Joaquin and people like Alberto recognize that the lifeblood of Las Juntas is its water. Their work must inform new economic growth and improved mining and ranching practice. It must also be part of a broader sustainable solution that protects the environment, maintains the well-being of its inhabitants, and offers economic opportunities for all members of the community.

C<small>HAPTER</small> 4

Las Juntas

Plate 4.1 Oldest street in Las Juntas, part 1, 2010

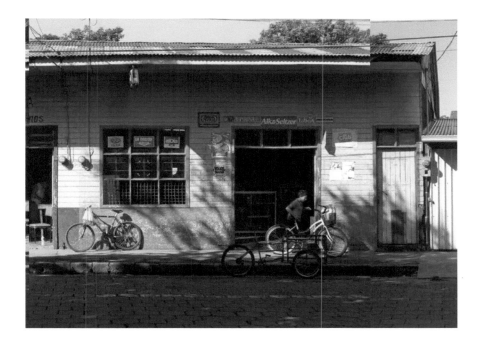

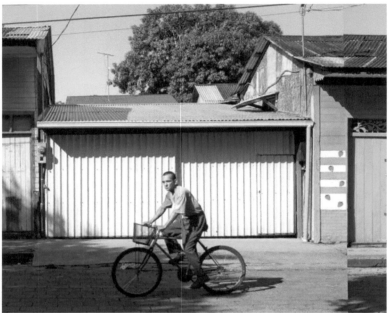

Plate 4.2. Oldest street in Las Juntas, part 2, 2010

Plate 4.3. Oldest street in Las Juntas, part 3, 2010

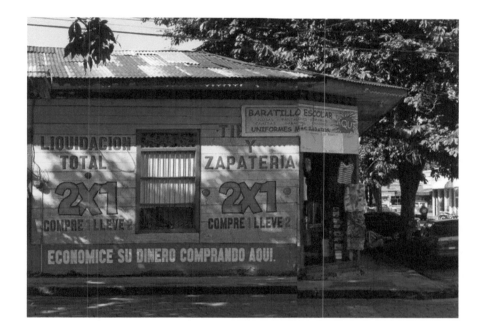

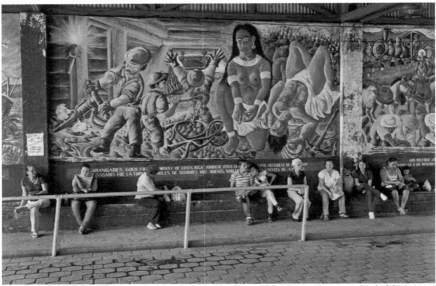

Plate 4.4. Mural depicting the history of mining, Las Juntas bus terminal, 2011

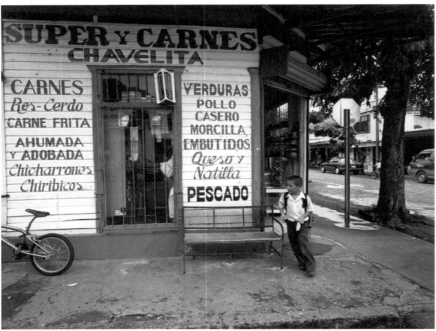

Plate 4.5. Butcher shop, Las Juntas, 2005

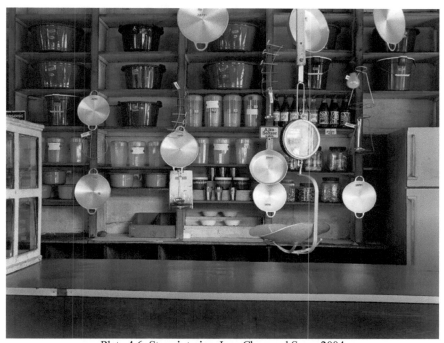

Plate 4.6. Store interior, Jose Chan and Sons, 2004

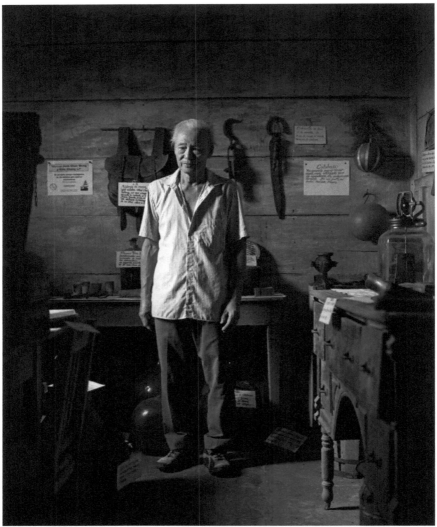

Plate 4.7. Walter Chan in family museum, Jose Chan & Sons, 2004

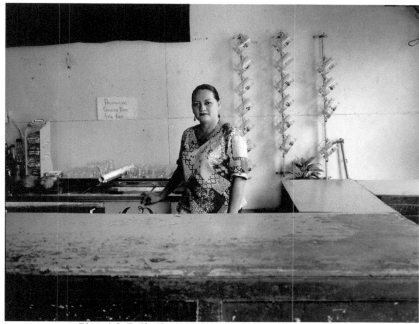

Plate 4.8. Delia Jiménez Ortega, owner of Bar 35, 2005

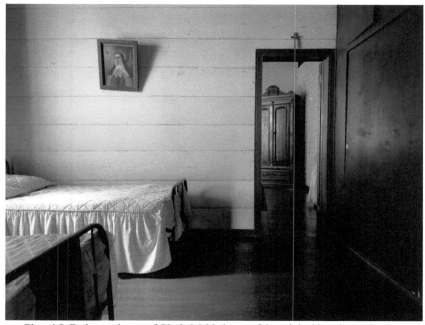

Plate 4.9. Bedroom, home of Gloria Mekbel, one of the original immigrant families
in Las Juntas, 2005

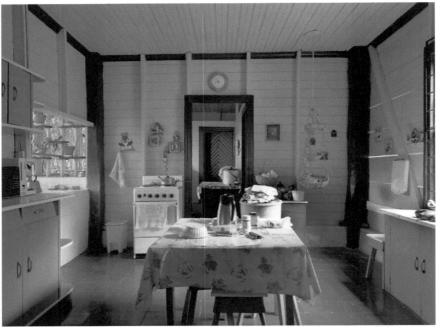

Plate 4.10. Kitchen, of home of the Lebanese family of Gloria Meckbel, one of the original immigrant families in Las Juntas, 2005

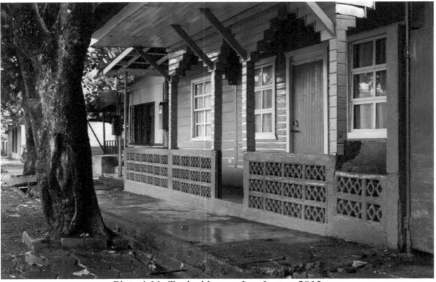

Plate 4.11. Typical house, Las Juntas, 2013

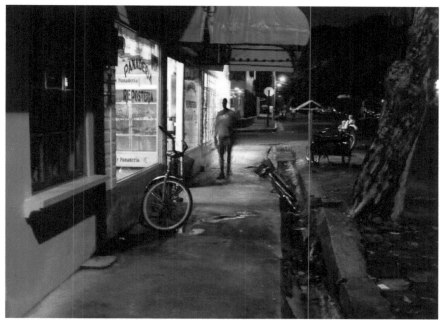

Plate 4.12 Street scene at night, Las Juntas, 2005

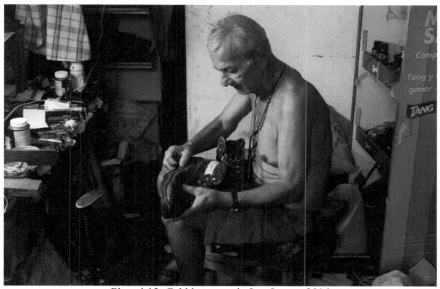

Plate 4.13. Cobbler at work, Las Juntas, 2016

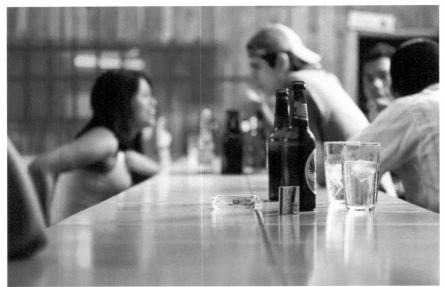

Plate 4.14 Evening at the bar, Las Juntas, 2011

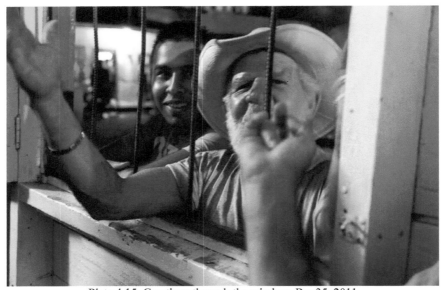

Plate 4.15. Greetings through the window, Bar 35, 2011

Coffee and Bananas to Gold

It is impossible to fully understand the current situation in Las Juntas in the absence of historical context. In this chapter, we provide that context as a story that really began to unfold with the northern economic expansion into the tropics in the late 1800s. We show the connection between agriculture particularly bananas and the development of industrial gold mining. As we do this, the role of foreign business and their economic gains favored by government connections and through the exploitation of the land and the people become clear.

COFFEE, BANANAS, RAILROAD, AND MINOR COOPER KEITH

As with our northwest journey from San Jose to the mining region of Las Juntas, the history of gold mining also had its start in the Central Valley. In 1821, the year it became independent from Spain, Costa Rica was sparsely populated with less than a 150,000 people. Perhaps as or more significant than the year Costa Rica gained its independence, was 1808 when the first coffee plants were brought to Costa Rica and planted in the mountains surrounding the Central Valley. By the mid-1800s coffee was the primary export product of Costa Rica with major markets on the eastern coast of North America. This proved to be challenging because there were no roads from the coffee growing region to Puerto Limón, the only potential port on the Caribbean coast. There was a more developed port on the Pacific side, Puntarenas, but without the Panama Canal it could not readily serve the eastern US markets for coffee on the Atlantic side that a Caribbean port could.

As the coffee trade grew, so did the economic and political interest in building a railroad that would connect the three major cities of the Central Valley, Alejuela, Heredia, and San Jose and the high mountain coffee farms with the potential port of Limón on the Caribbean coast. The first concession to build a railroad was offered to North American, Richard Farrer in 1854, but by 1869 this effort had failed. The job proved difficult to engineer, the physical challenge of the work was extreme, and the small population could not provide a sufficient supply of labor or tax revenue to support the project.

In 1872, General Tomás Guardia became president of Costa Rica and committed himself to linking the Central Valley with the Caribbean port by rail, viewing this as Costa Rica's only "means of salvation." His putative savior would be another North American, Henry Meiggs who had success in building railroads in Peru and Chile. To lead this new effort, which was started in 1872, Meiggs brought in his two nephews from Brooklyn, NY, Henry Meiggs Keith and Minor Cooper Keith. Cooper Keith would lead things at the Caribbean end, setting up camp and a store for the workers.

Cooper Keith's arrival at Limón after a treacherous 200-mile horseback ride from San Jose over dangerous mountains and through jungle suggested to the locals that this man had some heroic qualities, and this estimation of character would only grow with time. Cooper Keith decided to import labor from China and other Caribbean Islands such as Jamaica to get the job done. But by 1873, this effort to build the railroad also failed as the project was driven broke; some say due to the mismanagement of Meiggs who served as an absentee director of the project residing in the US.

Despite the failure to build a railroad, Cooper Keith prospered as a business man in the developing port town of Limón by exporting wood, coconut, and tortoise shell. In 1870, Cooper Keith brought a new variety of banana plant to Costa Rica, the economically superior *Gros Michel*. The success in growing the *Gros Michel* would transform the economy of the Latin American tropics, as well as the diet of most North Americans. The plants were productive in the Caribbean slope climate and soils, and because of this the Costa Rican banana industry began to grow. In 1870, Keith transported 250 bunches or stems of this new banana to New Orleans and nearly instantaneously created the banana boom. Because the banana market, like that for coffee, was primarily on the east coast of the US and the potential of this market was so great, interest revived to complete that railroad to the Caribbean port. Many felt the Cooper Keith was the only one industrious enough to achieve this goal (Stewart, 1964).

In addition to overcoming the challenges of designing and constructing a railroad through rainforest on steep terrain under harsh conditions, Keith was confronted with a serious labor shortage. The first attempt at constructing the Panama Canal was directly competing with his effort to attract labor to this project. The labor shortage was solved by Keith's vision to import Chinese labor, and later in 1888 when the canal project was halted freeing up more local labor. By 1882, the Costa Rican government had defaulted on its payments to Keith and could no longer meet its obligations to the banks from which it had borrowed to pay for the railroad. Keith was able to raise his own funds from US banks and private investors, and by 1890, primarily due to Keith's persistent industrious nature, the railroad connecting the Central Valley and to Limón was complete.

Keith actually lost money in the construction of the Atlantic Railroad in Costa Rica, but gained two important things from the accomplishment; land and power. Because Keith completed the railroad and was able to renegotiate the Costa Rican debt on the project to much lower rates, the newly elected Costa Rican President, Próspero Fernández Oreamuno, gave Keith 800,000 acres (3,200 km²) of tax-free land along the railroad, plus a 99-year lease on the operation of the train route. These terms were made official in a document signed by Keith and cabinet minister Bernardo Soto Alfaro on April 21, 1884 that became known as the "Soto-Keith Contract". As a result, Keith would eventually acquire approximately 5 % of the total territory of Costa Rica. As important as this massive land acquisition was Keith's new-found power. The completion of the railroad, his role in negotiating Costa Rican debt reduction, and his adventurous personality made him a national hero. His marriage to Senorita Christina Castro Fernandez whose father was President and then

Chief Justice of the Supreme Court of Costa Rica, and also a cousin of Soto, contributed to this rise in power and to his membership of the Costa Rican elite.

Despite the fact that Keith did not get wealthy from constructing the railroad, his other business ventures proved more successful, and the banana was in many ways his financial windfall. By 1890, twenty years after that first 250 stems of bananas was shipped to New Orleans, Costa Rica was exporting well over 1 million stems and this was primarily under Keith's control. The growth of the banana industry relied on the exploitation of both the ideal natural resources of Costa Rica including rich soil and plentiful water, and labor that were mostly brought to Costa Rica's Caribbean slopes from Jamaica. Keith led the transition from small farms to large, more efficient plantations. Given the successful completion of the railroad and in light of his financial losses in doing so, Keith was able to negotiate very cheap rates of transport and to acquire more land for banana production.

By 1899, Keith was exporting 3 million stems to New Orleans and New York (Stewart, 1964). At this time there were over 100 firms cultivating and transporting bananas. Keith's holdings in Costa Rica, The Tropical Trading and Transport Company, grew to be a monopoly as did his similar operations in Panama and Columbia. With the objective of making banana production more efficient and stable, Keith merged his companies in Costa Rica, Panama, and Columbia with the competing Boston Fruit Company held by Andrew W. Preston. The result of that merger was the United Fruit Company which flourished to control banana production and transport networks in Central and South America, the West Indies, and the Caribbean. Competing only with the Standard Fruit Company, United Fruit maintained a near monopoly for much of the world's banana trade. Keith's methods of exploitation of the land and the people, and government influence led to the development of so called 'banana republics' that had lasting impact on Costa Rica, and other countries in Latin America and the Caribbean.

THREADS OF GOLD

One evening in 1896, there was a hurricane force storm that beat upon one of Cooper Keith's Caribbean plantations where he was staying at the time. The next morning, as the storm passed, an up-rooted tree revealed gold objects intertwined in its roots. Further exploration revealed numerous archeological treasures of gold, ceramic and jade artifacts that turned out to be dated from the pre-Columbian era. From that point on, Keith's hunt for gold was on, and his passion for finding gold artifacts led him and his laborers to unearth over 16,000 specimens (Stewart, 1968). Originally kept for his personal collection, Keith and his estate later bequeathed a substantial portion of this to the Brooklyn Museum. Other parts of the collection later ended up in the Museum of Natural History in New York. Keith has been criticized for yet another act of exploitation, this time the removal of cultural artifacts of significant value from their homeland. Others had argued that there was no museum in Costa Rica capable of handling these objects so exportation was essential for their preservation and exhibition. In 2010, The Brooklyn Museum agreed to return 4500 of the artifacts to the Costa Rican people as part of a culling of their collection, but asked Costa Rica to

raise $59,000 to pay for the first shipment (Taylor, 2010). Today, a substantial collection is displayed in the Pre-Columbian Gold Museum of Costa Rica in San Jose.

Keith's hunger for Gold was likely born out of these archeological finds, but it eventually led to a more systematic and eventual industrial approach to gold extraction. After all, if the pre-Columbian indigenous occupants of the land found gold to make these treasures, Keith would have presumed there must be more gold embedded in the rock and soil so he began to position himself for this possibility. In the first part of the 19th century, the volcanic rock of the the *Monteverde* geological formation was discovered to be laced with threads and flecks of gold that were formed through the process epithermal mineralization by geothermal waters. Known as the *Sierra Minera de Tilirán*, the potential wealth that this region had to offer had begun to be recognized; however, there had not been any large scale development of mining efforts because of the lack of communication and transportation among mining areas, and the inability to move gold for export. Instead mining consisted of small dispersed groups that combined resources to finance the importation of simple tools and mercury needed in the extraction process. There was very little foreign interest and available capital to facilitate gold extraction in any significant way. However, in the late 1800's with construction of the railroad and the development of a means of export for the banana and coffee industries, the economic potential for gold began to attract both national and international attention (Castillo Rodríguez, 2009).

This takes us to Abangares, where water is not the only natural resource that this watershed had to offer. Gold was first discovered and the first mine was established in the Abangares watershed in 1884 by Juan Vincent Alvarado Acosta of San Ramon, Costa Rica. Acosta operated the mine with the three brothers for whom the mine, *Trés Hermanos*, was named. By 1887 the mine was in full operation and ore was being processed at a plant outfitted with grinding machines in Sarmiento, Puntarenas. In 1887, Keith entered the scene when his partnership, The Anglo American Exploration and Development Company paid Acosta 47,500 pesos for the *Trés Hermanos* mine (Castillo Rodríguez, 2009). In 1891, this company was renamed the Costa Rica Pacific Gold Mining Company, Limited. Then in 1902, with $2 million in capital, Minor Cooper Keith started a new company, The Abangares Gold Fields, which took over the holdings of Pacific Gold Mining. At that time Keith also acquired a contract that was made between the Costa Rican government and another company led by Walter Joseph Ford Leatherbarrow, the Abangares Mining Syndicate. Leatherbarrow's 50-year contract for exclusive rights to mine in Abangares was transferred to Keith's Abangares Goldfields, totaling his concessions to over 30,000 Ha. Keith had assembled yet another regional monopoly (Montoya Gamboa, 1997).

As he had done with the railroad and banana industries, Keith was not only able to use his influence and his promise to develop the Costa Rican mining industry to obtain the largest gold mining concession in the region, but he was also able to negotiate exceptionally low rates of taxation. The taxation rate for general exports was 15%, but Keith paid a mere 1% tax rate for the first 25 years and a 2% rate for the second 25 years of his contract. Exportations peaked from 1910 to 1920, and with less than two percent of the profits taxed (Montoya Gamboa, 1997).

Keith's company, Abangares Gold Fields, controlled eight different mines in the region including one that shared the name of his former Boston Fruit Company. Others were included the aforementioned *Tres Hermanos*; and *Gongolona, Año Nuevo, Kroptins, Bochinche, Los Chanchos* and *La Luz*. Keith applied his industrialist sensibility to the harvest of gold and developed a sophisticated technical process and industrial plant for its extraction in La Sierra, a site about 5km up the Abangares from Las Juntas. The extraction process occurred at *Los Mazos,* or the hammers, a seven story processing plant was constructed of stone that was hand carved from local rock by Italian immigrant stone cutters. The mortar between the stones consisted of egg whites and sand.

Ore was transported from the various mines to *Los Mazos* via cable tramway or pulled up a switch back railway by small locomotives. One was named for Keith's wife Maria Cristina, and another named *La Tulita* for the wife of the manager of mining operations Señor Hito (Figures 5.1 & 5.2). On each of the seven levels of the plant, ten 1800 lb mechanized steel hammers crushed the rock that was laced with threads of gold or *hilos de oro*. Each hammer was run by a large electrical motor and each with bank of batteries to keep it running should the supply of electricity be interrupted. Many of the old timers recall how these hammers shook the earth for miles around as they pounded the rock 24 hours a day. A slurry of cyanide and water was used to pass the material to the lower levels where mercury was then used to form an amalgamation with the flecks of gold that were freed as the rock was pulverized. At its peak 100 tons of gold containing rock material was processed at *Los Mazos* every day.

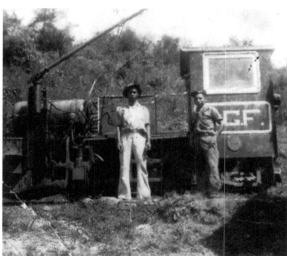

Figures 5.1. Locomotive near *Los Mazos* in early 1900s (Courtesy of Lilliam Román Zeledón)

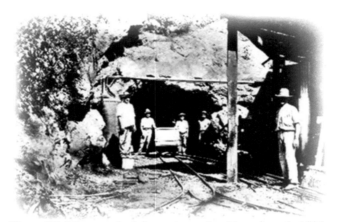

Figure 5.2. Miners and mining cart near *Los Mazos* in early 1900s
Source: Courtesy of Lilliam Román Zeledón

By the early 1900s, there were over 500 workers employed as miners or in the processing plant (Montoya Gamboa, 1997). Typically, miners worked from 6 AM until 4 PM with a 45 minute lunch break at noon. A similar night shift operated from 6 PM until midnight. Gold was extracted from tunnels and deep wells with in them, some as deep as 500 meters. The work was hard and dangerous, and the pay was extremely low. Tunnel collapse, silicosis, asphyxiation, and falls were among the greatest risks that the miners faced (Gamboa Alvarado, 1971).

Cooper Keith and his mining operations served to modernize and industrialize this rural, tropical region well in advance of other similar communities throughout Latin America or in the rural Unites States. Electrical, telegraph, and telephone service were brought to this region in the early 1900's. The mining was conducted on an industrial scale and depended heavily on the use of dynamite and machinery including grinders, rock sorters, air compressors, jack hammers and cable elevators. The grinders tumbled the extracted rock with hard stones of Australian origin, brought to Costa Rica as the ballast of merchant ships. A list of imports from 1893 through 1904, the period during which this operation was established, included steel, iron, Portland cement, wire, and thousands of crates of dynamite (Castillo Rodriguez, 2009).

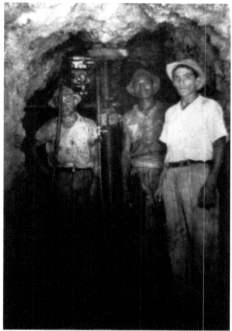

Figure 5.3. Miners in tunnel of *Tres Hermanos* mine near Las Juntas in early 1900s
Source: Courtesy of Lilliam Román Zeledón

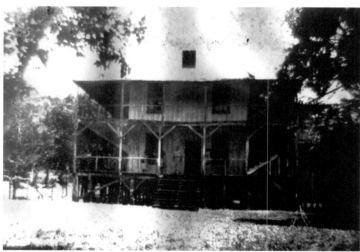

Figure 5.4. Company owned hospital in La Sierra in early 1900s
Source: Courtesy of Lilliam Román Zeledón

Down river, Las Juntas was colonized as a supporting commercial zone for both the mining and cattle industries. The town grew to fill a social and economic void functioning to meet the needs of the new immigrant mining community. Founded in 1892 by Antionio Arrieta, who had established a farm near the Abangares River, Las Juntas developed as a small, integrated city with land and business owners from Lebanon, Italy and China, and workers from Honduras, Nicaragua, and Jamaica. These immigrant business owners opened shops to provide the basic supplies needed by miners. Among them, there was a Lebanese family of Gloria Mekbel, who opened the first store on the main street of the town. Other early arrivals included the family of Jose Chang Wong, who came from China and opened a *pulparia*, or small store, to support the basic household and hardware needs of the miners.

For the most part the nuclear family was missing in Las Juntas. Those that arrived with families were offered company housing in La Sierra. In Las Juntas, a variety of small restaurants served food to miners, but more importantly, the women who ran these restaurants often served as their second mothers who provided a sense of unity and stability among the immigrant population. There was no church, but the priest would come periodically from the nearby town of Cañas to perform the sacraments[5]. Boxing was the sport of choice, but many people also played football, or soccer as it is called in the north.

Las Juntas would eventually become known as the *town without laws* because of its prevalent permissive lifestyle characterized by disorder, violence, liquor, and guns. Brothels housed prostitutes who arrived from the nearest city of Punta Arenas. Fights were common. There were gambling houses and dance halls where marimbas provided the music. The streets were and still are lined with a variety of cantinas serving both drink and food. One of the more popular watering holes, Bar 35, got its name for its price of a beer, 35 pesos which was half the going rate. Another bar, *Caballo Blanco,* located in the center of town was known for its *Guaro,* a sugar cane-distilled alcoholic drink named for the abbreviated *aguardiente* containing the words *agua* and *ardiente* which when combined roughly translate to "burning water". On pay day, the streets became rowdy with drunken miners who spent their earnings on *guaro.* On those days, the bar and store fronts would be shut tight selling liquor and beer only through the barred windows that lined the variety of establishments along the main street in Las Juntas.

Mining was a dangerous life conducted in the dark. As such, miners often referred to themselves as *mariposas de duro metal* or moths of hard metal. The diversions of Las Juntas were a necessary consequence of this hard life. Ofelia Gamboa Solorzano was a little girl when mining was at its peak in Las Juntas in the first half of the twentieth century. She lived well beyond the age of 90 years, and lived in a house across the street from the community library that bears her name. As the first kindergarten teacher in this community and author of a children's book celebrating her gold mining heritage, she represents the living history that is Las Juntas. Listening to her recount what life was like during the *Era of Gold* was like hearing tales of the California gold rush and the wild western United States. For Ofelia, it was an adventure to know the mines and the culture that came with it. She reminisces that the streets were no place for a little girl,

especially on the day that the miners were paid. Sadly, Ofelia passed away at the age of 94 in October 2018.

Las Juntas translates into English as "the gatherings", and explanations for this connotation vary depending on the conversation. Most say the name reflects the raucous gatherings in the center of down on the days that miners were paid. Others suggest that it represents the mixture of people and cultures that have been central to the town's heritage. Human communities in Guanacaste are not usually ethnically diverse, reflecting the uniform Mestizo or Ladino, predominantly Catholic mix of nearby Nicaragua. But because of gold, Las Juntas grew as an island of diversity. Still others believe that the name comes from the confluence of the three separate rivers to form the Rio Abangares that runs through the center of town. The ambiguity is comforting in this case reflecting the diversity in culture and perspective that are the heritage of Las Juntas itself.

Life was inextricably linked to the watershed and the rivers that comprise it. Gold mining and extraction was a water intensive process, and the rivers on which the operations were situated provided water for rinsing and moving the slurry of crushed rock flecked with gold. The river also received the silt, and unrecovered mercury and cyanide used in the extraction process. The people of Las Juntas were connected to the Abangares river not only as the source of their drinking water, but also through the harvest of fish and shrimp, water for irrigation, and for bathing and swimming. Early in the establishment of Las Juntas, a small dam was built a few kilometers upstream from the center of town to capture water and divert it through a series of aqueducts into deep trenches that line both sides of the streets. This created a constant flow of water throughout that town that was used to clean the streets, a vital function particularly needed after the festive nights of payday. The water was also used for horses, livestock, and in some cases, drinking. The flow of water through town created a pleasant cooling effect that soon became and remains an essential characteristic of Las Juntas.

LOS COLIGALLEROS

In addition to those employed by Keith's industrial gold mining operation, an independent group of artisanal gold miners developed in parallel. Referred to as *coligalleros,* these fiercely independent men extracted fist size pieces of stone from their tunnels with hand held sledges and pick axes. These stones were hammered into smaller pieces and then were ground down in *molino*s or hollowed cavities in stone that could receive the grinding action of a complimentary round large rock with a wooden handle. The fine pulverized material when spread out with water on a shovel looked like the tail of a rooster or *cola de gallo,* for which *coligalleros* were named. Rather than working for Keith's company, the *coligalleros* preferred a way of life that was free from a boss. However, their income relied on manual skills and hard labor, and they lacked the technology of the larger scale operations. Although they extracted and ground stone by hand, the *coligalleros* used mercury purchased at shops in Las Juntas like Jose Chan and Sons, for the final steps of amalgamation. In fact, until

recently the Chan's still had records of the large volumes of mercury purchased and ultimately released in the environment.

Cooper Keith's corporation distrusted the *coligalleros*, and the distrust grew with time. On July 8, 1912, Francisco Mora Valverde was accused of stealing 47 ounces of gold from Abangares Gold Fields and was detained in prison in San Jose. A number of attorneys came to his defense, a reflection of the anti-imperialist and anti-monopoly sentiment that was growing among the educated class in San Jose. It was later revealed that Mora Valverde actually had bought the gold, but this proof of innocence emboldened Keith's desire to preserve his profits from potential thieves, and the independent miners were frequently searched and accused of stealing any gold found on their person (Castillo Rodriguez, 2009).

The distrust of the *coligalleros* eventually extended to all miners. Around the peak period of extraction, the company started regularly searching miners to limit theft. Troops were brought in from San Jose as a police force to act in the name of the government, but half of their wages were paid by the company (Montoya Gamboa, 1997). This demonstrated the collusion of the state and the company to exploit resources and labor. In addition, Jamaicans were hired as foremen to help control the theft of gold, primarily because their native language was English and the North Americans in control of the mines could communicate with and trusted them. Upon leaving the tunnels, miners were required to register with the foremen and were subject to abuse and full body searches. On December 20, 1911, Juan Rafael Sibaja was killed by a Jamaican foreman, shot as he walked to the powder house where explosive materials were stored, for not registering upon leaving the tunnel. However, Sibaja was not leaving for the day, but rather was sent by another foreman to retrieve some dynamite, so he did not feel the need to register. In what became known as *La Huelga* (or strike) *de los Negroes*, the miners rose up against the oppressive Jamaicans, killing many with sharp pointed candle holders that were normally driven into cracks of the rock to light the tunnels (Montoya Gamboa, 1997).

As with the construction of the railroads and the banana industry, once again we see a double exploitation of both the land and the people in the extraction of gold as a way for foreigners to maximize profits. Forests were cut, soils eroded, and waterways were poisoned with mercury and cyanide. Mortality rates of the miners were high, caused by tunnel collapse, silicosis and tuberculosis through exposure to dust, and other industrial accidents. Ofelia Gamboa recalls the saying, "Yankees from hell pile the dead for greed," in reference to the mining related deaths at the hands of Minor Cooper Keith and his associates.

In the 1930s, the yield of the mines began to decline. Mining was no longer profitable, and the global economic crisis of that time began to take its toll on the company that relied on North America for its financial capital. Abangares Gold Fields abandoned its extraction operations and sold its rights to the Compañía Minera Y Explotadora de Costa Rica in 1938. This company worked through the 1940s mainly by leasing mining rights to individual *coligalleros*. With the end of large scale mining, the seven story *Los Mazos* quickly became an industrial ruin as locals extracted all of the usable materials from this structure and plant life gradually recaptured the site. The economy of Las Juntas was left to redefine itself as well, its people without the dreams and wealth that gold mining

had promised. The short-lived mining heritage slowly began to disappear.

In Exchange for Gold

CHAPTER 6

Los Coligalleros

Plate 6.1 Miners on the road to Tres Hermanos mine, 2012

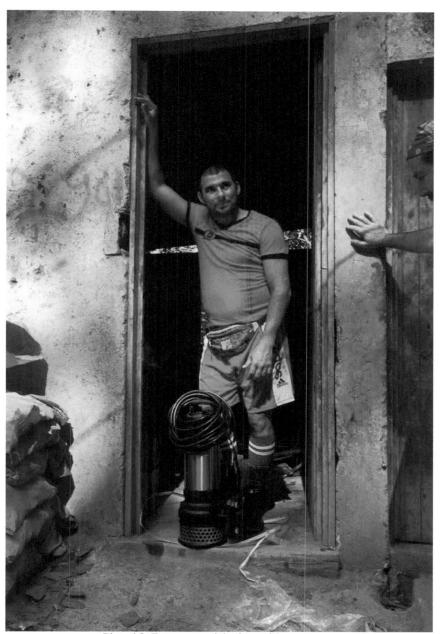

Plate 6.2. Entrepreneurial miner with new pump

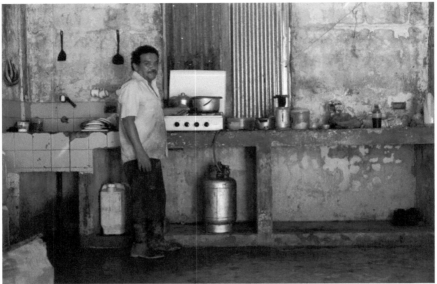

Plate 6.3. Preparing food for the miners, Tres Hermanos, 2013

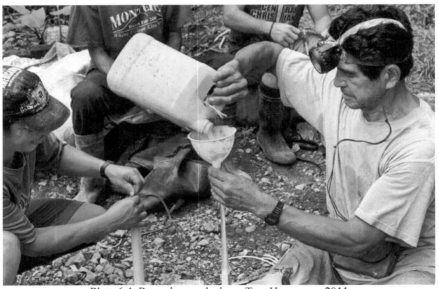

Plate 6.4. Preparing explosives, Tres Hermanos, 2011

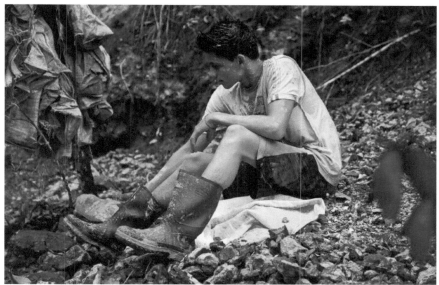

Plate 6.5. Young miner, Boston mine, 2010

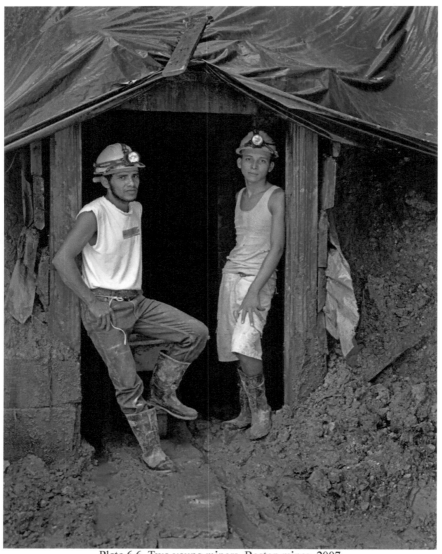

Plate 6.6. Two young miners, Boston mines, 2007

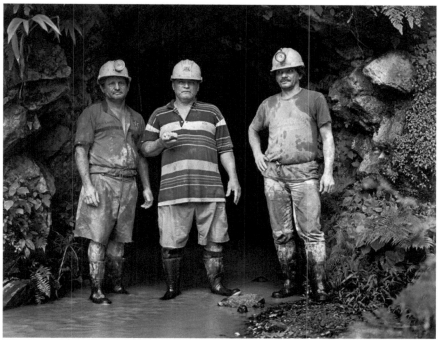

Plate 6.7. Three miners at a tunnel entrance, Tres Hermanos, 2004

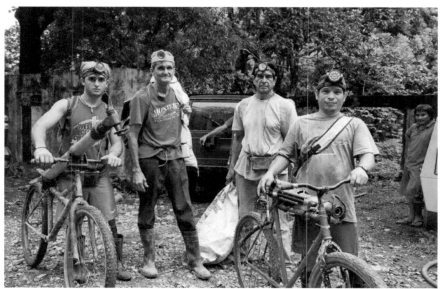

Plate 6.8. Four miners with equipment, Tres Hermanos, 2011

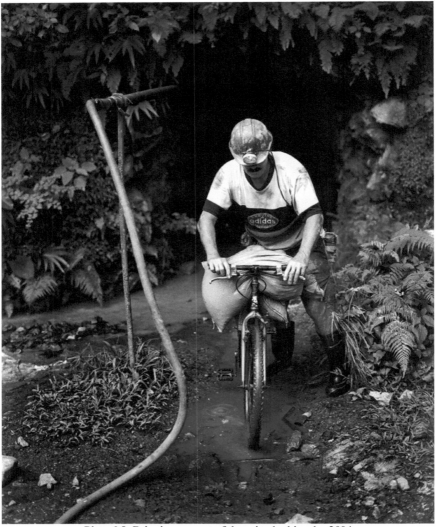

Plate 6.8. Bringing ore out of the mine by bicycle, 2004

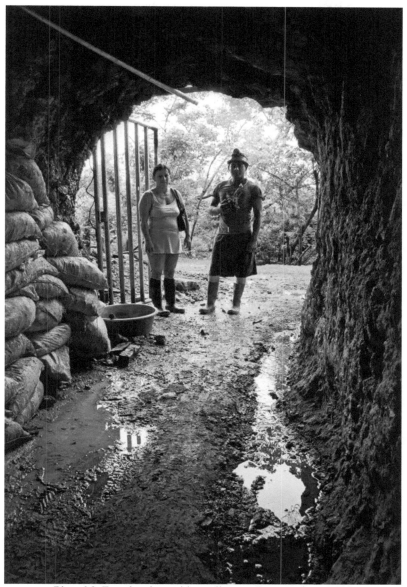

Plate 6.9. Female miner with a colleague, Boston mines, 2010

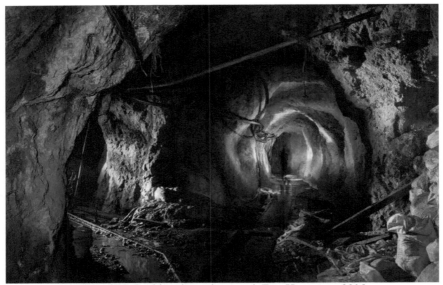

Plate 6.10. Looking down the tunnel, Tres Hermanos, 2016

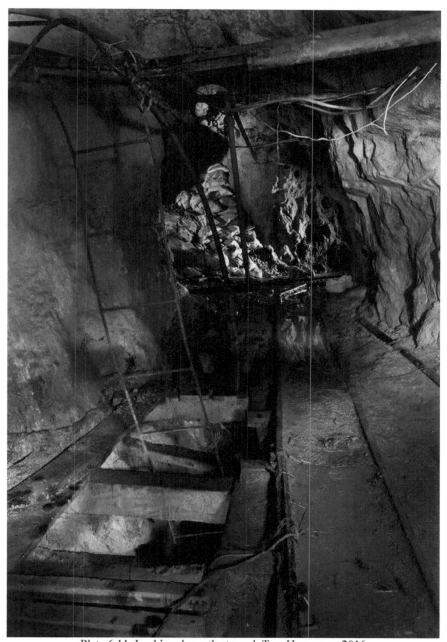

Plate 6.11. Looking down the tunnel, Tres Hermanos, 2016

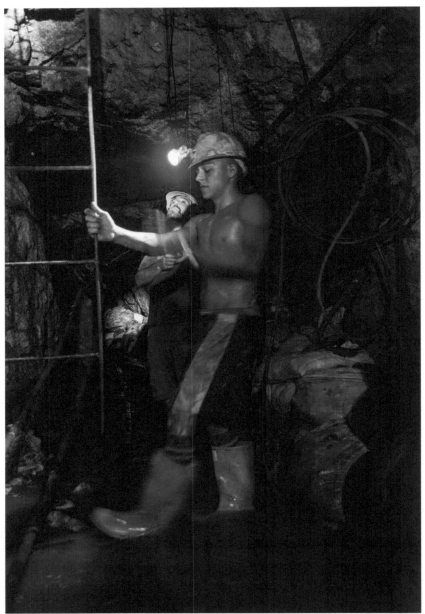

Plate 6.12. Preparing to climb to upper levels, Tres Hermanos, 2017

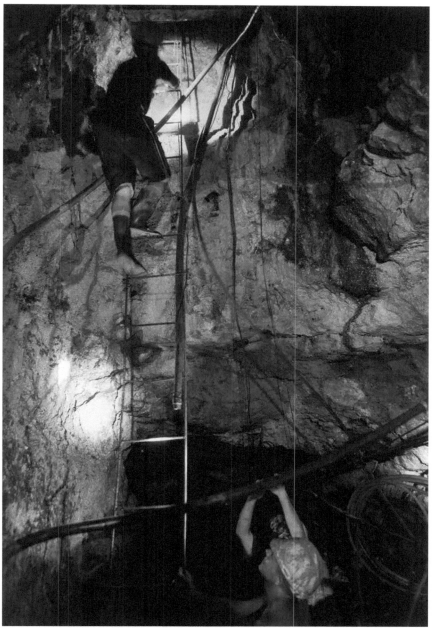

Plate 6.13. Climbing to upper levels, Tres Hermanos, 2017

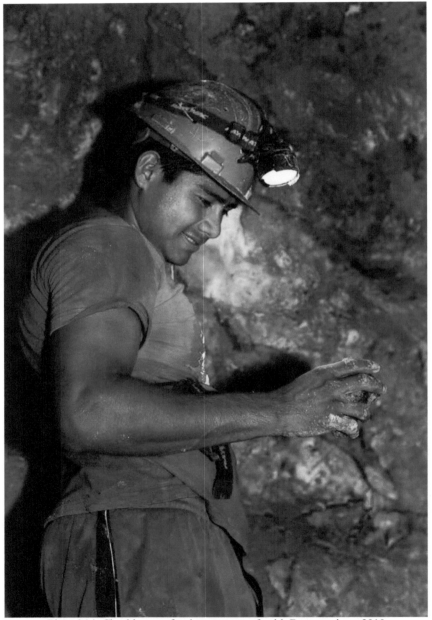

Plate 6.14. Checking ore for the presence of gold, Boston mines, 2010

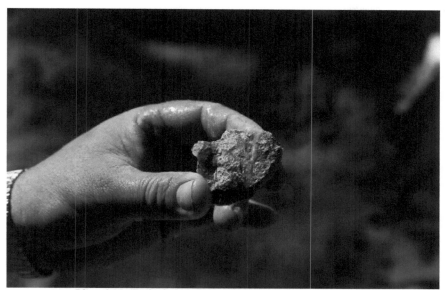

Plate 6.15. Typical size of ore brought out of the mines, 2017

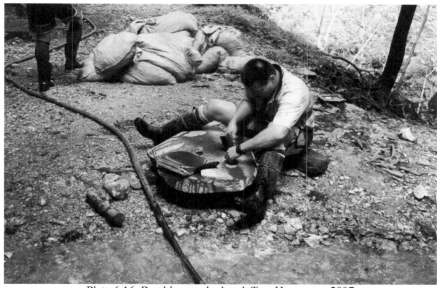

Plate 6.16. Breaking ore by hand, Tres Hermanos, 2007

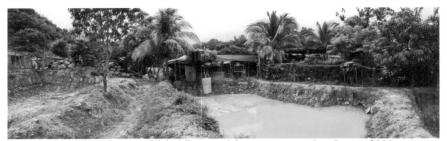

Plate 6.17. Rastra with holding pond for waste water, Las Juntas, 2011

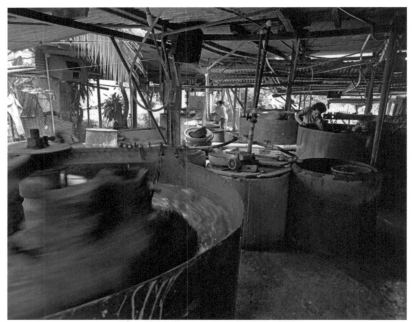

Plate 6.18. Rastras, Las Juntas, 2004

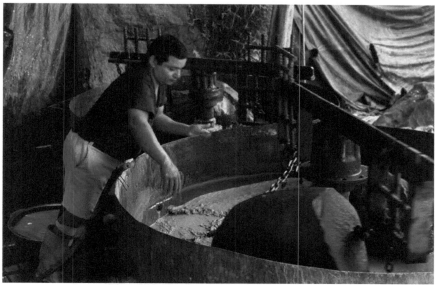

Plate 6.19. Tending a rastra, Las Juntas, 2017

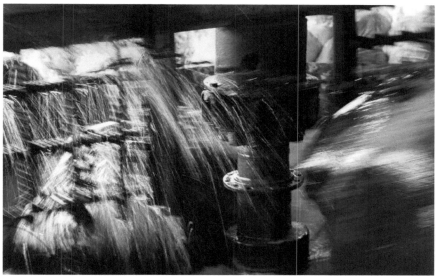

Plate 6.20. Working rastra, Tres Hermanos, 2016

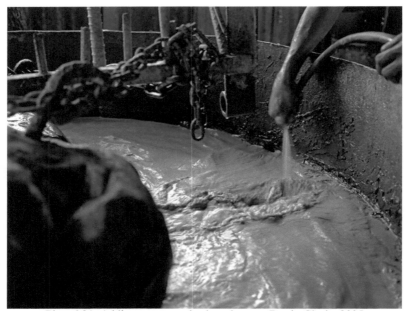

Plate 6.21. Adding water to a backyard rastra, Barrio Gloria, 2005

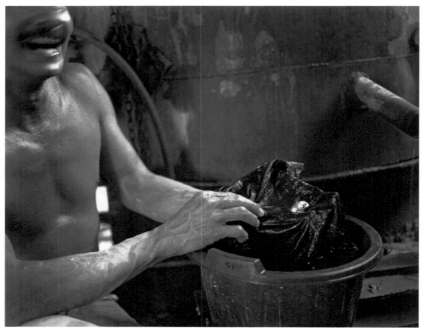

Plate 6.22. Miner displays amalgam of mercury and gold, Barrio Gloria, 2005

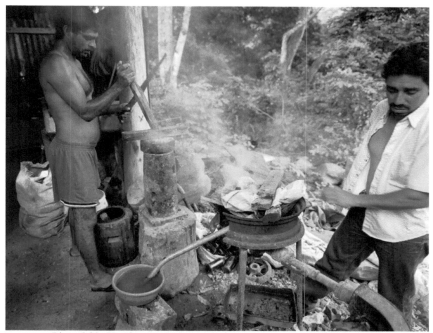

Plate 6.23. Heating a retort to vaporize mercury, Barrio Gloria, 2005

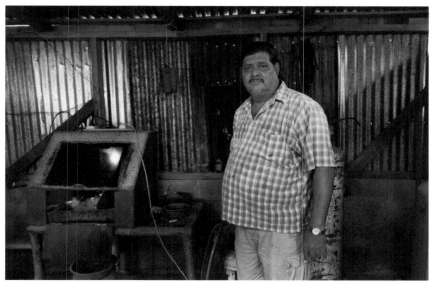

Plate 6.24. Miner with enclosure for burning off mercury from amalgam, Las Juntas, 2013

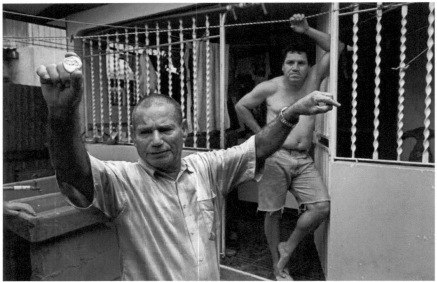

Plate 6.25. Miner with rastra owner, displaying pellet of refined gold, Las Juntas, 2011

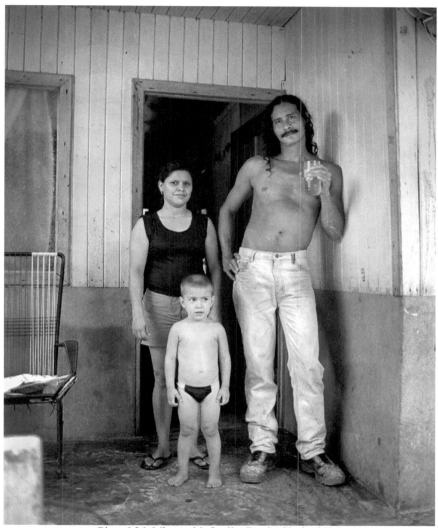

Plate 6.26. Miner with family, Barrio Gloria, 2005

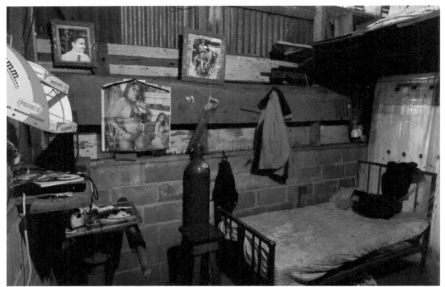

Plate 6.27. Miner's sleeping quarters, Las Juntas, 2013

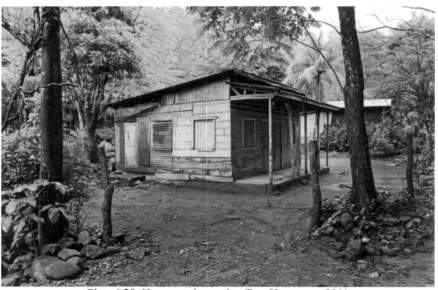

Plate 6.28. House on the road to Tres Hermanos, 2011

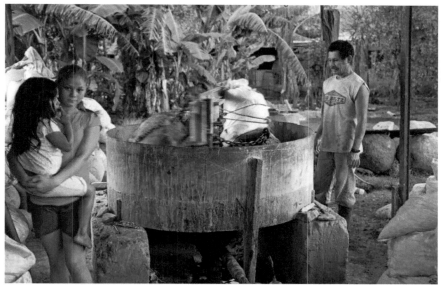

Plate 6.29. Family in backyard rastra, San Juan Grande, 2009

Plate 6.30. Daughter of miner, San Juan Grande, 2010

Plate 6.31. Woman miner San Juan Grande, 2011

Plate 6.32. Daughter of miner demonstrates new hammer drill, San Juan Grande, 2011

Plate 6.33. Man who worked as a miner during the industrial era, Las Juntas 2011

In Exchange for Gold

The Rise of Artisanal Gold Mining

Although the era of industrial gold mining in Las Juntas ended in the 1930s, many of the remnants of its history remain. There is a proud mining heritage and many are happy to share the stories from their parents and grandparents who lived and worked in that time. The culture and way of life especially the buildings continue to reflect the past. Artifacts from that period are proudly displayed in homes, businesses, and now at a museum located at the site of the processing plant, *Los Mazos*. However, the story does not end here. In this chapter, we will explore the continued work and resurgence of artisanal miners in Las Juntas, and the contemporary problems associated with it. Ultimately, our goal is to explore solutions to these problems within the framework of sustainability.

LOS COLIGALLEROS

In spite of its ethnic and social diversity, the community of Las Juntas remains drawn together and very proud of its common mining heritage. Residents share experiences rooted in the exploitation of their families and the environment by North American mining companies that occurred from 1898 until the 1930s. They have vivid memories and tales of this exploitation, and the accompanying decadent consumption that was central to their commercial economy.

After the early 1930s when it was no longer profitable to conduct large, scale industrial mining and foreign interests left the region, the *Coligallero* or artisanal gold mining continued. However, the extent of this waxed and waned depending on the global price of gold and other employment opportunities. These miners worked as individuals or in small groups who leased access to the tunnels mostly along the Boston River up from where it merges with *Rio Aguas Claras* to form the Abangares. They used small, basic equipment to grind their harvested rock, but the use of mercury and cyanide was still an essential part of the extraction process. By the 1950's there was very little mining activity, and the economy of Las Juntas felt the squeeze as the industry that brought about the growth of this town dwindled.

The global economic expansion of the 1980's brought with it a slight resurgence in mining to the region. In 1986 Valiente Ascari S.A., a subsidiary of the larger Canadian mineral extraction firm, Ariel Resources Ltd., established itself at the Tres Hermanos mine on the steep hillside that rises above the center of Las Juntas. Employing nearly 300 miners who worked the 10 underground tunnels at this site, this company's presence refocused everyone's attention on the heritage of exploitation. Now with only makeshift equipment, miners worked deep in the tunnels; and asphyxiation, scoliosis, and death from tunnel collapse that were common in the past then returned. Gravity and the flow of water drew the mining contaminants, silt,

cyanide and mercury, from the mountain top site into the community and its rivers. Wages rose and fell with the global price of gold, and ultimately in 2001 when Valiente Ascari withdrew from the area, they stiffed the miners for two months of unpaid wages, reinforcing an already bitter regard for company work (Montoya Gamboa, 1997).

In 1986 in addition to selling the right to mine to the Canadian subsidiary, the Costa Rican government offered access to the mines in the form of a permanent accession to any *Abangero* or person from Abangares in recognition of their heritage and prior exploitation. As a result, there are now large numbers of independent miners, organized in a variety of ways, who work the abandoned tunnels and remnant processing equipment. Poorly equipped, they put themselves, the environment, and the public at risk. The miners laboriously chip away at rock deep inside dangerous tunnels, and haul out sacks of fist-sized chunks on their backs or on bicycles. They occasionally use a type of home-made explosive to blast away rock to expose new veins of quartz that contain the small flecks of gold.

Once out of the tunnel, the chipped rock is reduced further in size by pounding with a hand-held hammer and then brought in sacks to small processing operations referred to as *rastras*, which directly translated means to drag or dredge. Located behind modest homes along the Abangares river and other parts of the community, these *rastras* consist of motorized machines that drag large chained boulders over the mined material within circular steel metal tubs about 4 to 5 feet in diameter. This pulverizes the material and frees the micro-flecks of gold from the parent rock. To collect the gold flecks, mercury which naturally forms an amalgam with the gold, is added to the turning mixture. In essence the mercury soaks up the gold like a sponge, making it easier to collect. The mercury-gold amalgam is collected by hand in a piece of cloth as the slurry is drained from the bin. The result is a semi-solid ball of mercury and gold. The waste material, including mercury and gold that have not been amalgamated is drained into settling lagoons and can potentially move into the surrounding environment.

The captured amalgam of mercury and gold are separated using heat in a primitive retort or still, essentially boiling off the mercury, which has a much lower melting and boiling point than the gold. Much of the vaporized mercury is recaptured through condensation in the retort, but certainly not all of it, as made evident by the need to regularly replenish the supply of mercury. The final step is to burn off the remaining mercury with an acetylene torch and to form the remaining gold into an ingot.

No effort is used to protect those working at the *rastras* from exposure to mercury and mercury vapor. There are no respirators, no protective gloves or clothing, and no ventilation hoods or equipment in use. Mercury exposure to the workers, the families in the immediate area, and the environment is certain. We have measured and detected mercury accumulated in the soil and the hair of pets and children occurring near these operations.[1]

[1] Unpublished preliminary data using a Lumex Mercury Analyzer (Ohio Lumex) to measure mercury concentration in hair and soil samples. Hair samples ranged from 0.006 to 0.233 µg/dL (n=4) and soil samples ranged from 0.014 to 1.35 µg/dL (n=6)

Through 2018, the global price of gold continued its climb and varied between 1100 and 1700 USD per ounce. This rise is expected to continue. However, the average price a Las Juntas miner is getting for their gold is about half of that, around $650 per ounce. On an average day, a miner can yield 2-3 grams of gold or about 0.09 ounces, producing a daily income of about 58 USD. The fee to process 1 gram of gold at a *rastra* is about 10 USD plus the cost of mercury and other supplies. Thus, the resultant profit for a day's work is about 30 USD depending on the price of gold. Clearly individual *coligalleros* are not getting rich, but are merely sustaining themselves and their families by the only means available to them.

There is no centralized location for the placement of *rastras*, instead they are scattered in throughout the community behind homes; and along creeks and rivers, and agricultural fields. As of 2018, there were more than 300 *rastras* in Las Juntas and the surrounding communities. As one walks through these communities, continuous sound of small engines and grinding rock can be heard. A cottage industry that supports these small scale mining operations has emerged and grown in the last five years. Most hardware stores have sections with mining equipment including chisels, sledge hammers, hard hats, lanterns, and mercury retorts. A small workshop where *rastras* and other types of mechanical processing equipment are constructed is now located in the community. They purchase sheet metal and other mechanical and electrical parts from industrial suppliers and can construct a *rastra* or a rock crusher (*quebrador*) in two weeks which they can sell for about 7000 USD dollars each. A *rastra* can also be leased and used on a weekly basis for about 300 USD.

The *coligalleros* organize themselves in a variety of ways. There are small operations where a *patrone* or boss pays a handful of miners for regular work, but keeps all of the gold. The *patrone* invests in all of the necessary equipment including the *rastra*. The *patrone* can take in 3-4 million Colones or 6000 to 8000 USD per week, while paying individual miners 80,000 Colones a week or about 140 USD. In addition to providing the capital, *patrones* have been known to support their workers in other ways. In one case when a miner was killed in an accident inside of the tunnel, a *patrone* offered 2.5 million Colones or about 5000 USD in compensation to the surviving family, not exactly an insurance windfall, but better treatment than the larger companies offered in the past.

We have seen the arrival of foreign interests who tend to have a bit more capital for equipment such as compressors and trucks. In the past 15 years, individuals from Mexico, Cuba, and Peru have run small operations, but most of them have been short lived, lasting a year or two.

There are also a number of *syndicatos* or cooperatives of up to 80 miners that are operated democratically, with profits divided equally. Each *syndicato* has access to its own rastras. Membership, access to the mines, and individual contributions are self-regulated. One of the larger groups that works the Boston Mine and another called *Coopeoro* each include 50- 80 members. However, most people working the mines do so in small familial groups, with siblings and neighbors sharing resources and income alike. These smaller groups either use their own *rastra* or pay to use one.

Remarkably, as these groups and individuals work the same resource, there has been little or no conflict. There have been no reports of competition for access, fights,

or theft or vandalism of equipment and harvested material. Some miners indicate that when they find a rich vein or *bonanza* as they call it, they tend to keep quiet about it and work it around the clock, but these have been few and far between. Perhaps the generally low concentration of gold that occurs throughout the Abangares region and the laborious effort necessary for extraction make the return so low that competition remains tame.

PRIDE AND INDEPENDENCE

No matter how the miners are organized, their gold is primarily sold to local agents at well below market price, who then transport and sell it in San Jose. Alvaro Cardero Torres expressed pride about participating in his family tradition of gold mining in Las Juntas. An independent miner who owns and operates his own *rastra*, Torres appreciates the liberty of working his own hours and being directly compensated for the gold he himself collects from the mines. The love of independence is what we most frequently hear as the most valued aspect of the *coligallero* lifestyle. A 21 year old miner by the name of Melvin told us that mining is "beautiful work" and that he can work whenever he wants, he is his own boss, and when he earns enough he can stop without losing the opportunity to return. His 30 year old friend Alexander, a miner since the age of 15, loves the freedom and it is the only kind of work that he has ever known.

For many there are really no other options for work. The community of San Juan Grande just up the road from Las Juntas is built on a former cattle ranch that was acquired by the Costa Rican government and subdivided into 5 ha plots for small scale farmers and smaller plots for subsidized or free housing for the very poor. Other than small-scale farming, there are few economic opportunities here and as a result many have turned to mining. The sound of *rastras* grinding ore can be heard throughout the neighborhood.

One such miner is a woman, Maribeth Gutièrrez Oviedo, who works with her two sons in the mines bringing the rock back to the two *rastras* behind their house. As a single mother of four, mining is really her only option for work, and she appreciates the flexibility it provides. She has become an expert at handling homemade dynamite and working the rock. Although she has been able to support her family through mining, Maribeth has seen her share of hard times. In 2009 a flood destroyed the car which had been her means of transport to and from the mines. She also had become sick, some say with cancer, but could not afford medicine or treatment. Miners are not officially employed and pay no taxes. Because of this they lack access to the social security healthcare system. Maribeth's teen-age daughter Patricia cares for her young sister while Maribeth and her sons are at the mines, and then attends high school classes at night in hopes of preparing herself for a future that does not include mining. This is a difficult yet typical situation for those whose work has so many risks.

ENVIRONMENT AND HEALTH

It takes 10-25 g of mercury to produce 1 g of gold. The mercury is threatening the ecology and public health of this community (Viega, Angelico-Santos, and Meech, 2014). Miners told us that they purchase it from foreign mercury dealers for about 230 USD per 100 kg. These are presumably black market dealers. Based on estimates of mercury use in 2009 when only 80 rastras were in use on average for 18 days per month, it was estimated that approximately 1400 kg of mercury were released into the environment every month[2]. Now with nearly 300 rastras in use for longer periods of time we expect this release to exceed 6000 kg per day. Mercury in its various forms, including the extremely toxic organic form, methyl-mercury, can be persistent in the environment.

Mercury evaporates very easily and can be inhaled into the lungs where it is taken up by the blood and then directly influences the nervous system. Miners handle mercury in its inorganic form, but as it is spills into the environment bacteria convert it to the more toxic methyl-mercury, which accumulates in biological tissue and becomes even more concentrated as it works its way up the food chain. When mercury-laden food, particularly fish, is consumed during pregnancy it can hinder the child's development, perception and level of intelligence. Methyl-mercury can alter protein function and structure in relation to the nervous system resulting in symptoms such as brain damage, mental retardation, trembling and paralysis (Aelion. 2009).

Miners exposed to mercury may not experience long term effects for a number of years so there is a perception that its use does not affect their health and often argue that it is safe to use. We have heard this repeatedly from miners that we interviewed. It has been shown that adult workers exposed to mercury are asymptomatic for up to 20 to 30 years after exposure at which point the on-set of associated muscle tremors, gum disease and mental disorders are often wrongly diagnosed (Calderón-Hernández, 2007).

Miners we interviewed tell us they purchase and use 1-2 Kg of mercury every day and all of them claim that they had no health problems and that if used correctly, it is not harmful. Others have told us that as long as a person has no open wounds then there is no way for mercury to enter the bloodstream. As such, miners freely mix and work with mercury with their bare hands. One long-time miner who we have interviewed over the years was adamant that mercury had no negative effects. Sadly, in 2014 he was in the hospital with neuro-muscular disease unable to enjoy the recent wealth his two sons acquired from a recent "bonanza".

There is other evidence, both scientific and anecdotal, regarding the negative impacts of mercury in this community. Dr. Ricardo Díaz Cajina, the Minister of Health of Las Juntas showed us anonymous (age and degree of exposure unknown) data on the blood content of sixty *coligalleros*. Of the sixty, seven had near toxic levels ranging from 1.0-2.3 ug/dL and eleven had levels higher that 0.5 ug/dL indicating exposure. Elvia Crustine Límenez, the director of the public elementary school noted that there are children in her school who come

[2] This is according to documents obtained by the Ministry of Health in Las Juntas in 2009 indicating that 80 rastras operating on average 18 days per month were releasing 1 Kg of mercury per day (80 rastras x 1 Kg X 18d=1440kg/d).

from mining families that suffer from difficulty in speech, walking, and limited attention and focus. Other teachers indicated that there is a rise in learning disabilities in the community and anecdotally attribute this to mercury exposure.

Most of the miners that we spoke to are more concerned about the dangers of working within the tunnels than about handling mercury. Miner Alvaro Cardero Torres expressed less concern about mercury exposure and mentioned that conditions in the mines are extremely dangerous and the chances of getting injured are high. This sentiment was confirmed by residents of Las Juntas who report that they regularly hear ambulances working their way up to the mines.

The waters of the *Río Abangares* eventually run into the Gulf of Nicoya and the Pacific Ocean where large international fisheries exist. Mercury is concentrated in fish tissues, especially swordfish and tuna, and can be dangerous for human consumption. Women who are pregnant are advised not to consume these fish because the mercury easily passes through the placenta to the fetus. Thus, mercury is not just an issue for the mining communities in and around Las Juntas. Mercury moves from the *rastras*, to the Abangares, to pacific fisheries, and ultimately to the global dinner plate. A recent study has shown that mercury is showing up in the tissues of jaguars in various places in Latin America, more evidence that the activity of gold miners has broad ecological impacts (Cuevas, 2013).

As in the early period of mining in Las Juntas, alcohol consumption is associated with lives of current day miners. There is no shortage of bars in Las Juntas and miners have been known to frequent them. Over the past 10 years, there has also been a notable increase in drug activity, mainly among younger members of the community. Our friends in the community often use the terms *minero* and *borracho,* or drunk, almost synonymously. One pointed out a bunch of beer cans near a *rastra* and pointed at them and said *Minero* or miner with some disdain. This may reflect a moral judgment pointing to possible class issues in Las Juntas. Many miners do drink; and some indicated that the associated lifestyle is consistent with the potential to binge. But for the most part, we have seen miners as hard working individuals proudly supporting their families.

THE RISING PRICE OF GOLD

As the price of gold continues to rise and other economic opportunities decline, the nature of artisanal gold mining is changing. There has been an increase in the number of miners including those that have arrived from outside of Abangares and in some cases from other countries. Mining has become increasingly more mechanized. Ore carts from the industrial past have been modified and are now pulled through tunnels on tracks recently constructed from wood. Air compressors, electric pumps, and the use of power drills and explosives have increased. Mining has become more territorial and conflict among miners is on the rise. Many rastra sites are now surrounded by large fences to both make them more obscure and to keep people out. Miners are now threatened by robbers and must remain vigilant. The peaceful era of the *Coligalleras* has come to an end.

With the recent surge in mining and its impacts on environment and health, local and foreign environmentalists attempt to discourage or regulate this activity. The Ministry of the Environment of Costa Rica (MINAE) occasionally steps in and closes down or enforces the relocation of poorly run rastras or those that are in moresensitive areas. However, a lack of funding for enforcement has kept these efforts minimal and short lived. With efforts to restrict mining and the use of mercury by people from outside of the community, the miners are ironically emboldened by a heritage that was once imposed on them by outsiders. This is a heritage of double exploitation that abused the people and poisoned the environment. It is a heritage that continues to result in numerous deaths within the mines, the ecological degradation of the of the rivers and landscape in this region, and the contribution of mercury to the local and global environment.

Costa Rica has a strong international reputation for its commitments to environmental preservation, health, education, and sustainable economic development. This has contributed to the rise of ecotourism as the largest component of their economy. Although it is less than thirty miles from major ecotouristic destinations, the community of Las Juntas is not realizing the benefits from the rapid growth in this sector. Tourist buses rarely stop in Las Juntas on their way to the more prosperous Monteverde, its cloud forest preserves, and zip-line and other attractions. Most tourists seem content with the illusion of rainforest as a museum of an Edenic environment, conveniently ignoring the hardscrabble existence outside the bus windows as they pass through town.

The people of Las Juntas have attempted to market their heritage by developing a mining museum. They call it the *Ecomuseo*, perhaps reflecting a connection between history and ecology, but more likely an attempt to market the place as an attraction for eco-tourists in case mining heritage alone is not enough to attract visitors. Unfortunately, few nature or history enthusiasts from other nations visit the museum or the town, as they do many of the foreign owned attractions throughout the rest of the country. The museum, however, has served to preserve this community's cultural heritage for its own people, a benefit not to be underestimated.

As the global price of gold continues to rise and other economic opportunities decline, Las Juntas has rapidly returned to its roots as a community subject to the adverse health, environmental and social consequences of gold mining. On a recent visit, we observed the funeral procession for two miners who died of asphyxiation within one of the tunnels late one night. We are seeing an increase in the use of mercury still handled without any protection in the backs of homes where children play and gardens grow. The dangerous blasts from the explosives used to free rock within the tunnels are heard more frequently. We talked to an 18 year old man who spoke some English who worked in the tourism industry, typically known for its higher wages, but left it because he felt that the potential gain from mining had become so much greater. We saw the constant run-off from the mines and rastras enter streams that eventually lead to sources of drinking water, agricultural fields and other natural habitats. We also witnessed the continued social problems of alcohol and drug abuse often associated with this economy.

In Exchange for Gold

CHAPTER 8

The Sustainability of Artisanal Gold Mining

Since 2004 the global price of gold has risen from below 300 USD to as high as 1800 USD per ounce. This increase in value along with the concurrent slowed overall economic growth and decreases in other types of employment opportunities is what has moved Las Juntas into this new era of gold. More and more families are depending on gold mining as their only source of income. With this has come a transition from a more peaceful *coligallero* way of life to one of rising tension. Where conflict was once rare, there is now competition for access to mines. Groups of miners have purchased land with tunnel entrances and exclude others from accessing those mines. Surprisingly given the peaceful nature of Costa Rican culture, in 2017, one young man, Eleodoro Ramírez, was killed while looking for gold as a way to obtain money to buy food for his family. Locals say that he was killed for being a *sucuchero*, a name given to those who steal gold from others (Esquivel, 2018). With increased mechanization more material is being removed and processed adding negative pressure on both the environment and human health.

The current situation has raised the level of concern of the Costa Rican government, environmentalists, and public health officials causing them to consider regulation and restrictions of both mining and processing. This has included the shutting down and relocation of *rastras* from environmentally sensitive areas, and prompted some officials to propose restricting artisanal gold mining or making it completely illegal. Even those mines with entrances on privately held land would be subject to such restrictions because Costa Rican law dictates that the government owns and has ultimate control of the mineral rights below the surface of that land. These threats have caused even greater tension among those miners who make their living from gold.

A SUSTAINABLE FUTURE

It is important to consider the current and future situation in Las Juntas and in other gold mining communities within the context of sustainability. An activity is typically considered sustainable if it serves to meet the needs of the present without compromising those of future generations by considering opportunities for economic development, environmental protection and resource management, and human welfare including social justice, equity, community enhancement, and public health. Sustainability moves beyond the protection of the environment by recognizing that without considering the quality of life of the human communities that depend on the environment, its protection will be compromised. Another key component of any sustainability related regulation, program, or policy is that it must be created though a

participatory and transparent process. This is particularly important in the case of the people of Las Juntas, given that their gold mining heritage was originally forced on them from the outside, and that it would be no less imperialistic for outsiders to deny them that heritage and the opportunity to continue it.

Simply banning artisanal gold mining or the use of mercury as proposed by some will not work. It would intensify the tension among the miners, the community, the government, and environmentalists. Outlawing mining would delegitimize the only means miners have to make a living and provide for their families. By driving their work both literally and figuratively underground, the prohibition of mining would force miners to take even more risks and improperly acquire, handle, and dispose of mercury. Moreover, if mining were illegal it would become more difficult or impossible to provide resources such as training and incentives to improve the safety of their work (Wade, 2013). Because a ban on mining would undermine the economic opportunity for a large part of this community and would intensify the risks to miners and the environment, it is not a sustainable solution given the criteria provided above.

Mining does provide economic opportunity for many who lack other means of income. However, working conditions are hazardous, and the economic gains have not typically been equitable with most of the miners working as poorly paid laborers and the majority of profit going to wealthier land owners, gold exporters, and ultimately to those in foreign markets. Furthermore, artisanal gold mining in Las Juntas misses on most of the other criteria for sustainability. It is clear that the current situation has negative impacts on the environment, public health, and general quality of life in the community, particularly for those with limited opportunity for economic advancement. The future of this community will depend on sustainable solutions that consider each of these criteria developed in a transparent manner with input from all stakeholders, including the miners and their families. Here we offer some suggestions as a starting point for progress towards each of these criteria, and urge the establishment of a local committee or agency that can bring all of the stakeholders to the table to explore and develop them.

One solution would be to develop and offer a centralized location for processing gold that incorporated greater health and environmental standards. A key component to this would be to make such a facility easily accessible and more affordable to miners. Taking the *rastras* and the use of mercury out of the community and away from the rivers, homes, schools and agriculture in a way that would benefit miners makes sense. One challenge would be to consider the potential economic loss of individuals who primarily make their living operating their own *rastras* and leasing them to miners.

Another possibility is to educate and provide resources to miners so that they can improve their practice. There is the potential for developing cleaner and safer ways to use and dispose of mercury (UNIDO, 1997). But even more promising is the existence of alternative technologies that do not use mercury and are actually more efficient at extracting gold resulting in potentially greater profits for miners (Wade, 2013). One of these methods uses cyanide rather than mercury. Although it too is toxic, MINAE's Geology and Mining Office argues that cyanide is much safer to handle than mercury (Esquivel, 2018). Also, the yield is much higher using cyanide procedures. With mercury, miners recover less than 40 percent of the total gold from

the ore removed from the tunnels, while with cyanide they can recover as much as 90 percent. But this technique requires expensive equipment and technical experience both of which limit the access to this approach. However, with government support and through the formation of cooperatives or consortia that could pool their resources the construction of such facilities may be a possibility. With aid from outside investment, one such facility has been constructed near Las Juntas. However, it is obscured behind high fencing and is heavily guarded benefiting primarily the few investors.

Another extraction technique that should be more accessible to most miners is the mercury-free gravity borax method of gold recovery. Using this technique the powdered ore collected from the *rasrta* is either panned or run down a carpet or felt covered sluice in order to separate the heavier materials which tend to contain gold. The collected material is then mixed with borax and water. The heavy mineral concentrate mixture is then heated in a clay crucible until it becomes molten. Because the borax lowers the melting the point of gold, the molten gold accumulates at the bottom of the crucible where it can be collected once it cools and is solidified (Appel and Na-Oy, 2012).

Changing a well-established practice has its challenges and often requires economic incentives (Viega, Angelico-Santos, and Meech, 2014). However, trials have shown that the borax gravity method can increase gold yield three fold over the mercury amalgamation techniques (Appel and Na-Oy, 2012). Miners will also save money as the high cost of mercury is avoided. This solution that increases the economic return for miners while eliminating the use of toxic mercury has considerable potential for making gold mining more sustainable. It will, however, take resources, time, and broad participation and acceptance to make this transition. This has been successfully done in the northern Philippines through teaching and training programs where miners could see through demonstration the greater yields and cost savings associated with this method. A program funded by the Danish government is helping to further disseminate this knowledge using this demonstration techniques which they have found to be much more effective than focusing solely on the environmental and health benefits (Appel and Na-Oy, 2012).

Another key component to sustainability is vertical integration or the concentration of all stages of production. Currently in Las Juntas, gold is sold in its raw form and is transported to San Jose. Later, usually outside of Costa Rica, the gold is made into consumer products that when sold offer a larger proportion of profit. One way to keep those profits in the community or at least within Costa Rica may be to develop and market end uses of the gold such as jewelry or art that can be sold in the community especially to tourists. Again, the development of such a trade would require a substantial training program including both the craft of working with gold, and business and marketing skills. Microfinancing, or small low interest loans for entrepreneurial activity, may be one useful tool in supporting the development of new gold-related businesses. These are often a part of economic development programs offered by NGOs or governmental development agencies.

Costa Rica is a demonstrated leader in tourism development that is primarily focused on ecological and adventure travel. With some government support, the community of Las Juntas has worked hard to develop tourism in relation to the history

of this town and its gold mining heritage including the construction and operation of a mining museum, *El Ecomuseo,* at the site of the former industrial processing plant (*Los Mazos*). A tourist agency in Las Juntas, *Mina Tours*, offers several gold-themed tours that include visits to the *Ecomuseo*, abandoned and currently worked mines, operational *rastras*, and opportunities to talk to present day miners. Unfortunately, this effort has not yet been very successful at tapping the flow of foreign tourist dollars that is abundant elsewhere in the country.

We encourage further development and marketing of gold related tourism that might attract travelers that are moving between the popular Pacific beaches and high altitude tourist spots such as Monteverde. Coupled with opportunities to purchase gold locally, this represents a real economic opportunity for miners and the community, and could serve to make Las Juntas an attractive destination for those interested in purchasing gold products while learning about this community and its gold mining heritage. Other countries have fostered successful tourist attractions in communities associated with a specific craft or trade such as ceramics, silver, gold, woven products, and coffee.

Certification programs like those for fair trade coffee and chocolate, sweatshop-free clothing, eco-bananas, and conflict free diamonds and precious minerals offer opportunities for consumers to make ethically-based purchases. Products from these programs are often priced higher, but offer the knowledge and satisfaction that their purchase is not at the expense and exploitation of the producers or the environment. A goal of these programs is to provide greater economic equity and to support the communities and the environment from which these products come.

A certification program could potentially be applied to gold. This would allow and motivate the miners of Las Juntas to extract, process, and market gold as environmentally friendly. One challenge to this "green gold" approach is that once gold enters the global market, it is nearly impossible to trace it back to its source (Wade, 2013). So new market structures that allow tracking would need to be developed. The non-profit organizations Fairtrade Gold and Precious Metals and the Artisanal Gold Council have begun working towards increased transparency and traceability of gold, reduced mercury emissions and elevating the livelihood of participating mining communities by giving them access to improved markets. A number of retail outlets for ethical and sustainable jewelry are beginning to emerge.

The sustainability of artisanal gold mining will also depend on broader efforts for economic development, environmental protection, and social equity. The Costa Rica government has been and must be committed to these efforts. One specific example is the provision of government incentives for watershed protection, including payment of farmers to develop riparian buffer zones. This incentive should be extended to miners and other non-farming land owners that live and work along the rivers. The achievement of broader objectives like these will require the continued support of local and national governments, and increased efforts from non-governmental organizations (NGOs). Community leaders should consider the development of a local NGO focused on preserving the health of the Abangares watershed as a whole that would broadly represent all stakeholders including miners.

Government has an important yet delicate role to play in improving the sustainability of artisanal gold mining. In response to the growing concerns related to

the increase in the number of *coligalleros* working the mines, government regulation is increasing. In 2015, it was reported that artisanal gold mining would be made illegal in Costa Rica, but by the end of 2018 this has yet to occur. Rising conflict among the *coligalleros* themselves has also resulted in government intervention. Since 2014, dispute over mining territory caused confrontations among the miners. This resulted in arrests, seizure of illegally extracted material, and the closure of tunnels (Esquivel, 2018). This sparked an economic crisis for those involved. Costa Rica's Deputy Minister of Political Affairs and Citizen Dialogue intervened in order to provide more effective solutions to this problem. This included efforts to improve inter-institutional dialog, greater transparency and temporary economic relief for the effected miners. Despite these efforts, the conflicts and lack of economic opportunities persist (Equivel 2018).

Recently, governmental efforts have become more effective. In May 2016, a large stakeholder meeting was organized in the town center of Las Juntas bringing together miners, other community members and government and non-governmental organizations. Their solution is to promote and require that all miners join one of four cooperatives that would then self-regulate. In return for ensuring sound mining practices these cooperatives would be given technical assistance, and financing opportunities to improve conditions and increased opportunities for development as described above.

This meeting was met both anxiety and excitement as 100s of miners began the process of joining cooperatives. A representative from one of them spoke in support of the many of the ideas discussed above. He made a strong argument that efforts to protect the environment and health can be done in a way that actually improves economic opportunities for the miners of Las Juntas, and are not necessarily exclusive of each other. There seems to both skepticism and hope about the changes being made and talked about. As of 2017, all of the miners that we spoke to had joined cooperatives. However, they indicated that there has been little or no monitoring beyond that.

The role of the cooperatives is evolving. One miner told us that although he and his family were officially mining at a site managed by their cooperative, they in addition, had purchased a farm with a mine independent of the cooperative that was their primary sources of material. With substantial investment, some cooperatives allow members to become associates who are more involved in the decision making and profit sharing of the mine. Those who are essentially laborers in the cooperative mines may invest a portion of their hourly wage overtime to reach this level of investment. This has created a more structured, entrepreneurial approach to mining where miners see a future beyond hard labor.

There has also been a large international effort to eliminate mercury from artisanal mining. In 2013 Costa Rica signed the International Minamata Convention on Mercury. In August 2017 it came into effect. This is a global accord that seeks to reduce and, ideally, eliminate the use of mercury in activities such as mining. As a signer of this accord, the Costa Rican government has stated that the use of mercury in mining will become illegal in 2019. The response to this has been surprising. The impending illegality coupled with potential increased yields and reduced costs of some alternative methods, has led the cooperatives to become more receptive to

exploring and adopting mercury-free extraction approaches. They have negotiated with the government a realistic time-frame for phasing out mercury and implementing new systems of extraction.

Gold mining in the area around Las Juntas is clearly in transition. A more sustainable future is seemingly more obtainable as the government works with cooperatives of miners and other stakeholders to develop solutions that will both benefit the miners while eliminating the use of mercury. However, this transition has been slow to gain traction. The role of government and other organizations in regulating and supporting fair and safe mining practice and other related economic activities remains to be seen. Only time will tell whether the next era of gold mining in Las Juntas will be one that is sustainable both protecting the environment and improving the lives of all members of this community.

A GLOBAL STORY

This has been a global story, one where global forces of outside industrialists and the price of gold have shaped a community over time. At the same time, the release of mercury from the work of *coligalleros* is contributing to the global pool of environmental mercury. Furthermore, this story is playing out throughout the world as small-scale artisanal gold mining like that in Las Juntas is globally abundant with high levels of activity in Latin America, Asia, and Africa. Artisanal and small scale gold mining is now the single largest contributor of global mercury pollution contributing more than 2,000,000 lbs of mercury per year or 37% of the anthropogenic contribution exceeding that of all coal-fired power plants combined (Wade, 2013). A global accord, the aforementioned Minamata Convention, has the specific mission to reduce or eliminate the use of mercury in mining.

This story about Las Juntas is a case-study that reflects the complexity of artisanal gold mining within historical, cultural, and environmental contexts. Our goal here has been to share this story through words and photographs to offer a better sense of this place, its people and the issues they confront. We have also attempted to offer an appreciation for the problem at large and perhaps motivate the development of sustainable solutions to these problems that can more broadly be applied in artisanal gold mining communities around the world. Finally, we hope this work generates interest specifically about the town of Las Juntas. We encourage you to visit, experience its cultural and environmental beauty, and to meet the people who have made this story.

Working toward a Sustainable Future

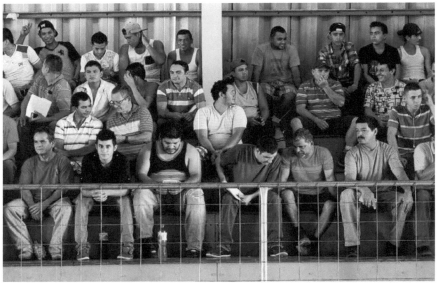

Plate 9.1. Meeting of miners for the formation of cooperatives, Las Juntas, 2016

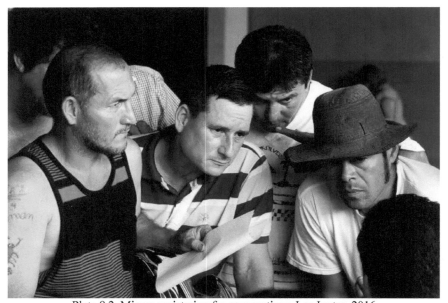

Plate 9.2. Miners registering for cooperatives, Las Juntas, 2016

Plate 9.3. Entrance to the elementary school, Las Juntas, 2016

Plate 9.4. Children near the elementary school, Las Juntas, 2011

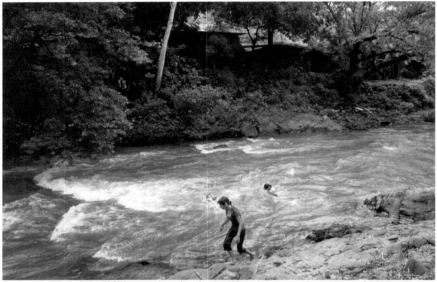

Plate 9.5. Children swimming in the Rio Abangares, Las Juntas, 2007

References

Aelion, C. M. 2009. "Soil Metal Concentrations and Toxicity: Associations with Distances to Industrial Facilities and Implications for Human Health." *Science of the Total Environment* 407 (7): 2216–23.

Allen, William H. "Biocultural Restoration of a Tropical Forest." *BioScience* 38 (3): 156–61.

Appel, P. W. U., and Leonicio Na-Oy. 2012. "The Borax Method of Gold Extraction for Small-Scale Miners." *Blacksmith Institute Journal of Health & Pollution* 2 (3): 5–10.

Biesanz, Richard, Karen Zubris Biesanz, and Mavis Hiltunen Biesanz. 1988. *The Costa Ricans.* Prospect Heights, IL: Waveland Pr Inc.

Calderón-Hernández, Jaqueline. 2007. "El mercurio en la práctica médica y sus efectos en la salud y el ambiente." *Mediographic Artemias* 64: 270–2.

Castillo Rodríguez, Antonio. 2009. *La Guerra del Oro: Tierra y minería an Abangares 1890-1930.* University of Costa Rica.

Cueves, Angélica María. 2013. "Jaguares, con mercurio en el cuerpo." *El Spectador*, April 11. Retrieved August 23, 2017. http://www.elespectador.com/noticias/medio-ambiente/jaguares-mercurio-el-cuerpo-articulo-415247.

Esquivel, Noelia. 2018. La muerte se viste de oro. La Voz de Guanacaste. Retrieved June 20, 2018, from https://vozdeguanacaste.com/la-muerte-se-viste-de-oro/

Gamboa Alvarado, José. 1971. *El Hilo de Oro.* San Jose, Costa Rica: Trejos Hermanos.

Janzen, Daniel H., ed. 1983. *Costa Rican Natural History.* 1st Edition. Chicago: University of Chicago Press.

———. 1986. *Guanacaste National Park: Tropical Ecological and Cultural Restoration.* Editorial Universidad Estatal a Distancia, San José, Costa Rica.

Montoya Gamboa, E. 1997. *Ecomuseo minero de abangares: revitalizacion del patrimonio nacional e historico cultural de una region minera.* Tesu de graduacion presentada ara optar al grado de licenciada en educacion civica.

McNutt, Marcia. 2013. "Mercury and Health." *Science* 341 (6153): 1430.

National Biodiversity Institute (INBio)—Costa Rica. 2014. "Biodiversity.*" National Biodiversity Institute (INBio)—Costa Rica.* Accessed August 23, 2017. http://www.inbio.ac.cr/en/12-inbio/conservacion.html

Stewart, Watt. 1964. *Keith and Costa Rica: A Biographical Study of Minor Cooper Keith.* Albuquerque: University of New Mexico Press.

Taylor, Kate. 2010. "Brooklyn Museum Hopes to Return Artifacts to Costa Rica." *The New York Times*, December 31.

United Nations Industrial Development Program. 1997. *Introducing New Technologies for Abatement of Global mercury Pollution: Phase II, Latin America.* New York: United Nations.

Viega, M. M., G. Angelico-Santos, and J. A. Meech. 2014. "Review of Barriers to Reduce Mercury Use in Artisanal Gold Mining." *The Extractive Industries and Society* 1: 351–6.

Wade, L. 2013. "Gold's Dark Side." *Science* 341 (6153): 1448–9.

CPSIA information can be obtained
at www.ICGtesting.com
Printed in the USA
BVHW020831180219
540523BV00014B/124/P

*9 7 8 1 8 6 3 3 5 1 2 4 9 *